STUDIO PORTRAIT PHOTOGRAPHY OF

Children

and Babies

SECOND EDITION

Marilyn Sholin

AMHERST MEDIA, INC. ■ BUFFALO, NY

Dedication:

Special thanks to all my clients who let me into their lives and have shared their children and families with me. Your children are all a part of my family.

This book is especially dedicated to the many people who are no longer with me. I know they are all reading the book "up there" and smiling down on me.

And to my son Ryan who always is following his dreams. Never stop dreaming.

To Michael: With love, thanks for all the love and laughter.

Published by:

Amherst Media, Inc.

P.O. Box 586

Buffalo, N.Y. 14226

Fax: 716-874-4508

www.AmherstMedia.com

Publisher: Craig Alesse

Senior Editor/Production Manager: Michelle Perkins

Assistant Editor: Barbara A. Lynch-Johnt

ISBN: 1-58428-069-7

Library of Congress Card Catalog Number: 2001 132044

Printed in Korea.

10 9 8 7 6 5 4 3 2 1

TABLE OF CONTENTS

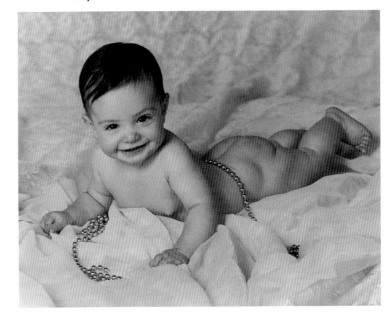

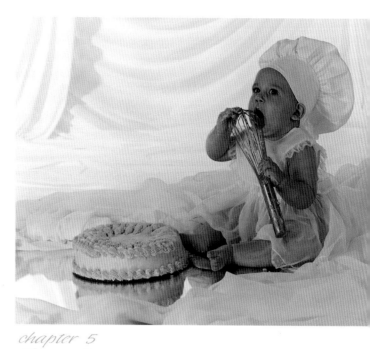

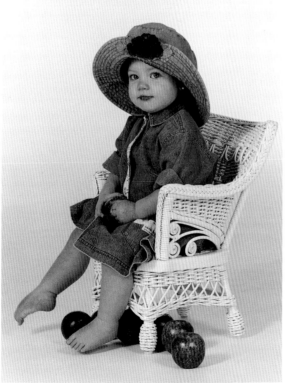

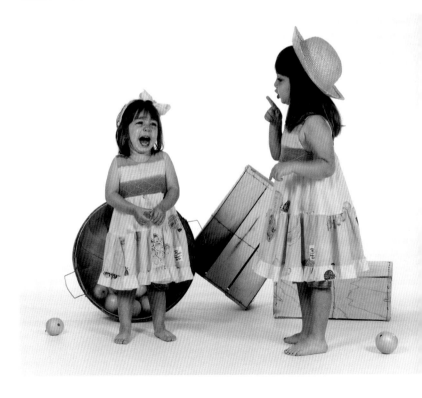

ABOUT THE AUTHOR

Marilyn's fascination with the visual arts started when she was a little girl and her two older brothers had a darkroom in the basement. She spent many hours there watching as her brothers created "magic" pictures that appeared in what looked like water in trays. Her fascination with the darkroom was enhanced at Halloween, when its eerie red light made the darkroom the best "fun house" on the block.

On her sixteenth birthday, the one gift Marilyn wanted most was her own camera. Her parents made her wish come true, and since then she has never looked back. The camera went with her everywhere, and the family counted on her to document all the family events. Her friends always knew they would be photographed when Marilyn was around.

Eventually, when Marilyn married and had children, she unpacked that old enlarger her brothers worked with and set up her own darkroom in her home. Now, it was her own son who watched in amazement as the prints of him appeared in the trays of chemicals. She scrimped and saved and sold things at the flea market to buy her first top-of-the-line 35mm camera. With the first roll of film she put through it, Marilyn won a national Kodak contest and had her picture

published in the newspapers. A natural? Good luck? Maybe years and years of learning to see and feel what transforms a *good* image into a *great* image.

Never looking back, Marilyn opened her first studio in her home and then moved it twice, eventually ending up in a state-of-the-art 2600 square foot studio. Her clients come from all over the United States, South America and Canada to commission her to create portraits of their families.

YOU MUST STAY ON TOP OF THE PHOTOGRAPHIC INDUSTRY AND BE READY TO INNOVATE QUICKLY.

Over the years, Marilyn's artistic style of portraiture has won national acclaim. Her award-winning photographs have been published in the Professional Photographers of America (PPA) Loan Book and in the Florida Professional Photographers Excellence Book. She is also a nationally recognized Certified Professional Photographer with Master Craftsman degrees.

Marilyn is a popular speaker at photographers' conventions, where she presents programs on many topics—from "The Art of Creativity" to how to achieve innovative family and children's portraits in the studio and on location. Her speaking has taken her from coast to coast and to the Caribbean. She also conducts workshops with hands-on experience for the attendees.

Marilyn has twice been honored by the National Association of Women Business Owners (NAWBO) as a finalist for the prestigious "Recognition" awards. She was chosen two consecutive years to photograph "Women of Distinction"—a black & white exhibition for the Crohns & Colitis Foundation of America. Her portraits were displayed at Saks Fifth Avenue in Bal Harbour, Florida.

Marilyn's philosophy is that you must stay on top of the photographic industry and be ready to innovate quickly. Keep an open mind and always look to the future. As she says to seminar audiences, "Set goals and be fearless about what you want to accomplish."

INTRODUCTION

The joy of photographing children is in their innocence and their spontaneous expressions. A glowing face or hug from one of our little people has brightened many gloomy days at the studio. Their expressions, captured in a fraction of a second, remain ingrained in our minds. Years later, they make us smile.

This book is for anyone who wants to learn how to photograph their clients or their own children better, more easily and with more pizzazz than before. There are tips and ideas for handling children and having fun while doing it. After reading it, you will find that everything about cameras and lighting that once looked so difficult is now clearer to you. The explanations are all presented in simple-to-understand terms that anyone can immediately begin using to improve his or her photography.

A bit of child psychology will help in preparing for each sitting. You will learn what to expect from each sitting. (And you will especially appreciate when you meet the perfect child who goes against the norm and follows all your directions perfectly.)

In chapter 1 there are tips for how to set up an effective studio and camera room. There are ideas for what to do to

create a friendly atmosphere that children will respond to—important for building your rapport with them.

Chapter 2 deals with the psychology of each age group that is photographed. Knowing what to expect from a newborn or a two year old will help in planning their portrait sessions. Having a few age-appropriate tricks up your sleeve for each subject will make things go smoothly.

Chapter 3 goes through a typical portrait sitting from the proper clothing consultation to exactly what to expect during photography. It will help take away some of the mystery surrounding what happens during a portrait session.

In chapter 4, we'll discuss the right equipment for the job—the kinds of lights, lenses, filters, reflectors and accessories that are the bare minimum required to create beautiful studio portraits. Knowing the right film for the job (chapter 5) and combining it with the right camera and lighting

The culmination of all your work behind the scenes is a memorable portrait that will be treasured for years to come.

will make things even easier. Simple lighting, the right lens and the appropriate filter will bring together the elements of beautiful portraiture (chapter 6). Learning how to properly use reflectors will also cut down on the need for extra studio lights.

No two people see and photograph the same subject the same way. Your style of photography (chapter 7) will leave a statement about you on the portraits. Just as important as taking the portrait is knowing how to sell and present your portraits to the public. Proper display of them is crucial to the final impression. Chapter 8 will explain how important these elements are to a successful business.

Lastly, if you are a professional photographer or an amateur who photographs your friends' children for fun, you'll learn how to put the cherry on the sale by giving your clients or friends great service after they receive their portraits. Nothing makes someone appreciate a gift or a piece of art more than personal contact with the artist.

If this sounds like a lot to cover in one book, it is. But I promise you that the read is worth the time and before you even finish this book, you will be using it as your reference before every portrait sitting. While other books may tell you generalities about child photography, this book gives you specifics you can use immediately. At the end of every chapter the book can be closed and something will have been learned.

YOUR STYLE OF PHOTOGRAPHY WILL LEAVE A STATEMENT ABOUT YOU ON THE PORTRAITS.

A good place to keep this book is by your camera. Hand in hand, the camera, lights and information here will make a better photographer of you, whether you are a professional or amateur.

THE CHILD-FRIENDLY STUDIO

Children are people. As long as you can remember that, you will be fine. They are people without pretense or arrogance. They will always say what they mean and ask the most embarrassing questions at the most inappropriate times. They will make you laugh and touch your heart. Their tears will break your heart. But beware—these little folks can also try your patience, bring your equipment crashing to the floor, ruin your backgrounds and in generally torment you for the time they spend in your studio.

The ideas included in this chapter will help to create an environment that (at the very least) gives the photographer the best odds of controlling the portrait session.

■ *First Impressions*

Children have already had many experiences before they come through the door to your studio. They have been to both pleasant and unpleasant places. You want them to identify your studio as a fun place to visit. It should be warm and friendly and, above all, *not* remind them of a doctor's office. They have probably been to their doctor's office more than any other place (except the mall) and don't likely have fond

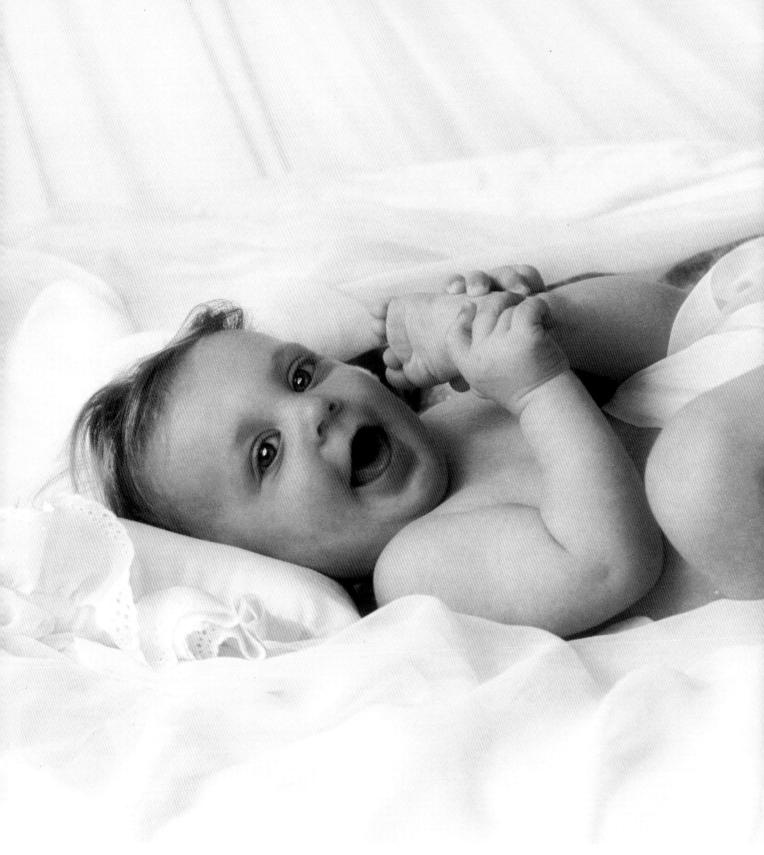

Angling the camera to look slightly down on the baby creates a more natural appearance and a fuller view of the child's body.

memories of it. You are a new adult in their life and someone who has personal interaction with them. They need to see you as a friend—a fun adult who loves them no matter what they do.

Your Appearance. Your physical appearance should convey the impression that you are Mommy's friend—no suits or ties, or long dresses with fancy jewelry. Casual, child-friendly jewelry and comfortable shoes will give the image of a friend—someone who has good intentions and wants to play with them. Get down on the floor with the children and interact. Always have toys or books in your reception room that the children can expect to see every time they come to

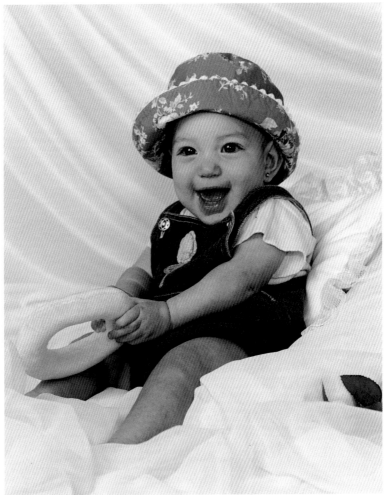

How much more fun can a baby be? This is the kind of portrait you have to smile back at.

your studio. This will reinforce the idea that your studio is a fun place to go to. They can look forward to playing again with a favorite toy there.

Toys. One item that works very well is a toy car that children can get into and beep the horn. This gives even the smallest toddler something to climb on, and the older child something to get into and move around. Have child-sized chairs for them to sit in themselves. You don't need to have a lot—just enough for two children. Seeing all these items in your reception room immediately sets it in children's minds that your studio is a place where they belong.

Overcoming Shyness. Even with these practices in place, however, don't expect every child to come through your front door and immediately be your friend. With shy chil-

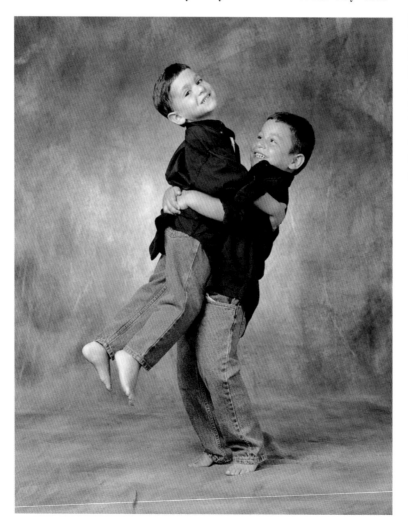

It's important to be aware of how the children interact when not being photographed. I saw the boys do this in the reception room and, at the proper moment, asked them to do it in the camera room. Their expressions are wonderful, and the portrait is a natural image of how they interact with each other.

■ *The Dressing Room*

The studio dressing room should be parent friendly. If they have forgotten (or just didn't think to bring) certain items, you should have them ready. Having these items on hand will make your life easier:

❏ Clean combs

❏ Baby hairbrush

❏ Regular hairbrushes

❏ Hair spray and hair gel

❏ Nail polish remover (Little girls often have chipped polish on their nails.)

❏ Cotton balls

❏ Cotton swabs for sensitive areas near the eyes that need cleaning

❏ Wet wipes

❏ At least three different tones of concealer for black and blue marks and insect bites

❏ Hair elastics in different colors

❏ Bobby pins

❏ Safety pins

❏ Scissors to cut tags off new clothes

❏ Hair dryer

❏ Hair curling iron

❏ Lipsticks in neutral and pink tones to add a little color

❏ Lip glosses in natural and pink for dry lips

❏ Petroleum jelly for stray eyebrows or hairs

❏ Numbing gel for teething gums (This is a lifesaver.)

❏ Steamer for clothes

❏ Diapers in a few sizes

❏ Tissues

❏ Stain remover wipes to remove spots on clothing (Use a hair dryer to dry clothing.)

❏ Child toothbrushes and dental floss

❏ Child's two step stool for them to use in the bathroom

❏ A tall director's chair (helps to raise children to comb their hair)

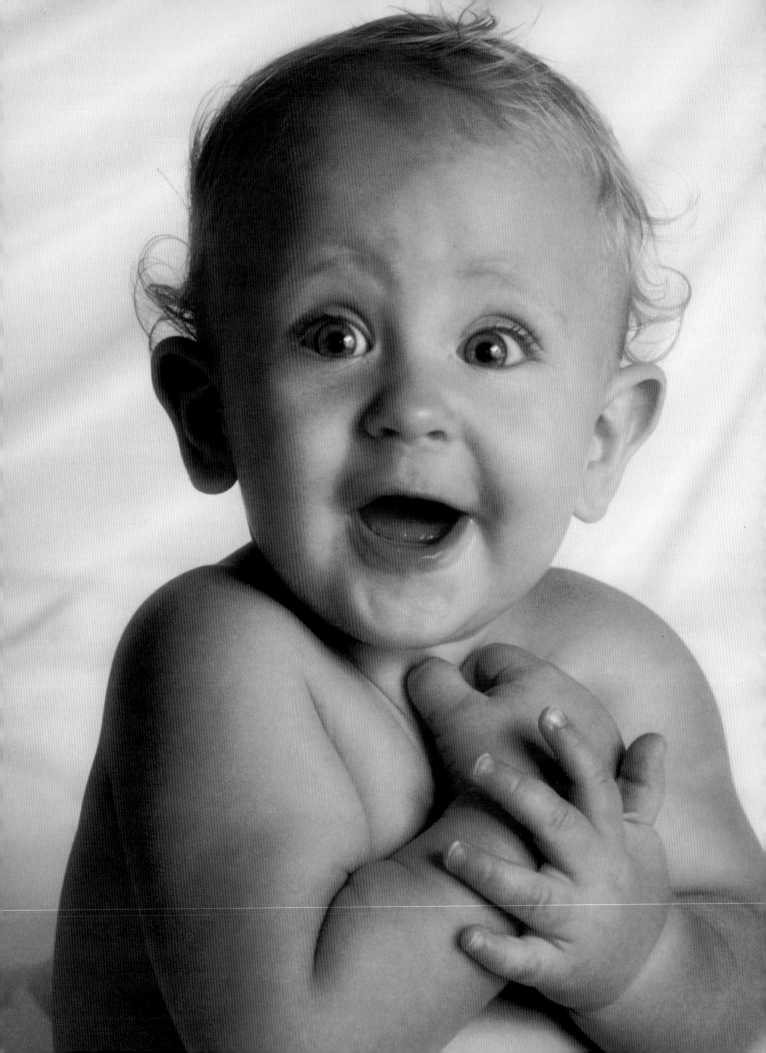

OPPOSITE: The pure white on white effect with only the baby's hands showing moves your eyes directly to his face. The straight angle of the lens placement makes you feel like you are practically in the photo with him.

NEVER LET AN UNATTENDED CHILD WALK INTO YOUR CAMERA ROOM.

dren, get down on their level and continue to talk to their mom—maybe while holding an appealing book or toy in your hands. Eventually their curiosity will win, and they will get closer and closer to you. Once you can make a connection (talking to them or reading a book), you can proceed to let them get ready to be photographed. The time you spend in your front room getting the children warmed up to you will cut down on the time you need to spend in the camera room trying to get good expressions.

◼ Your Camera Room

Never let an unattended child walk into your camera room. This sounds simple, but in the hectic moments of preparing for a sitting, it can happen. Always be in the room and prepared for the first setup you are photographing. Have the mom bring the child(ren) in, and don't let them wander. Immediately have them brought to the spot you want them to be for the portraits. Let mom stay just off to the side of the set to start out. Then she can move to the chair next to the camera once you see things are going well.

It is important that you maintain control of the children in the camera room. They must understand that *their* area to be in is the set and they must stay there. It is just as important to be sure that Mom isn't wandering around the camera room picking up age-inappropriate props to use for the sitting. Give Mom the job of sitting in the chair. Have signs around your prop area that parents can read—"Please Do Not Touch Props." They won't always abide by it, but it does help to discourage them.

When you finish with each setup, tell the child to go directly to Mom and sit with her in a chair to wait for the next one. Keep talking about what you will do next and how much more fun you are going to have together. Throughout the shoot, it is important to keep your interaction going with

the child. Psychologically, you are keeping them bound to you and listening to you.

■ *Conclusion*

Your studio, reception area and camera room should represent a place children want to return to. For the parent, it should be an easy place to be with their children. There should be no fear that they might break something or handle things they shouldn't. The props should be inviting and yet somewhat hidden so they never know what you will bring out next. Maintaining the element of surprise will help you to build interest in what is coming next. All of this will assist you in maintaining control of your studio and camera room.

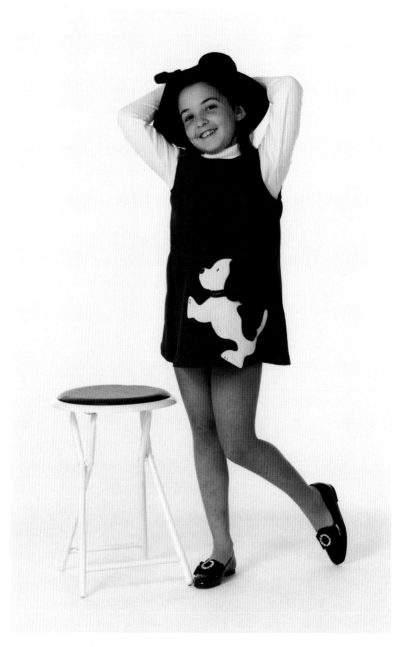

It's easy to get little girls to play at being models. Just let them be themselves. This rapport is started in the reception room and continued on into the camera room.

WHO'S THE BOSS HERE?

Photographing children and babies requires some basic knowledge of psychology and child developmental stages. Each age has its own set of pros and cons. Your job is to know what to expect at each age and to have an arsenal of tricks up your sleeve to deal with each situation.

Hints and Tips
"You're not the boss of me!" protests a grumpy child. It may be frustrating when children want to run the show in your camera room, but in this chapter, you'll learn to smile, get control of the situation, and say to yourself, "Oh, yes I am—but I don't want you to know that."

■ *Newborn to Six Months*
When photographing infants, plan enough time for them to have a schedule that is completely their own. While you will actually be photographing for only a short period of time, you must allow for a tired or hungry baby's needs to be attended to. Allow soothing time for Mom to walk the baby around a bit. One trick that often works is to take the baby yourself and calmly walk around talking to him softly. New mothers are usually very tense about their baby being cranky when they are expecting magnificent portraits. Babies pick up on this stress. You, on the other hand, can send warm and calm vibes to the baby by holding and soothing him. Keep your cool when an infant is crying and cranky. Remember, you only need a brief time span to accomplish your task. The important issue is to have a comfortable and happy baby.

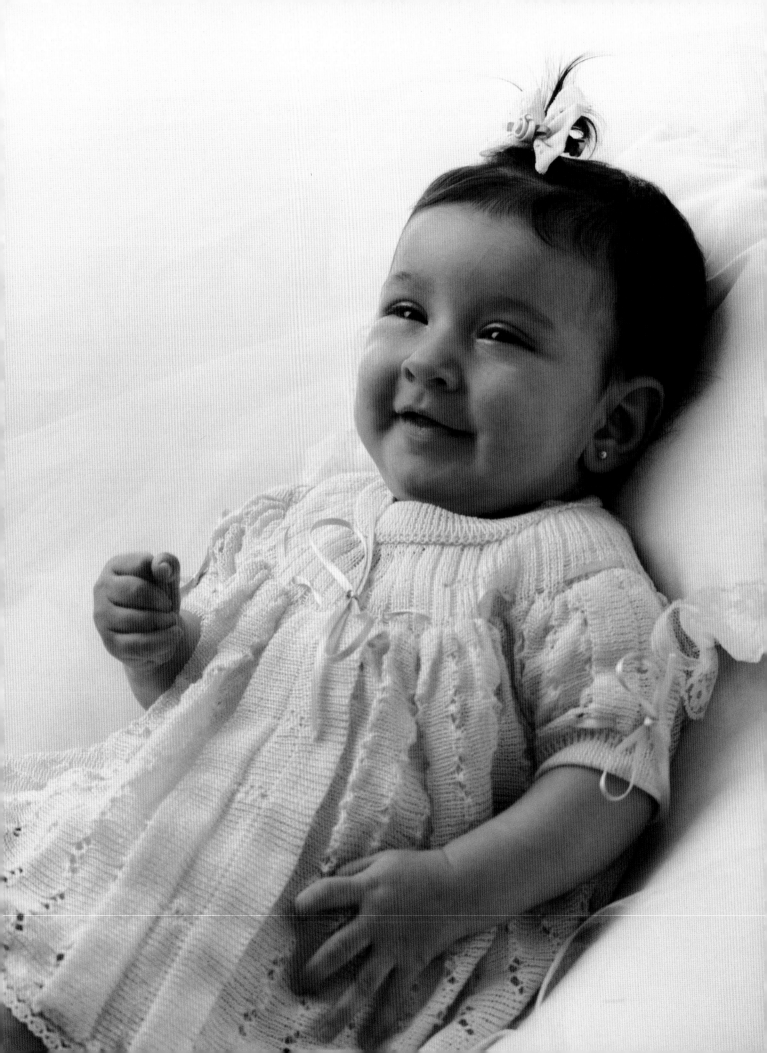

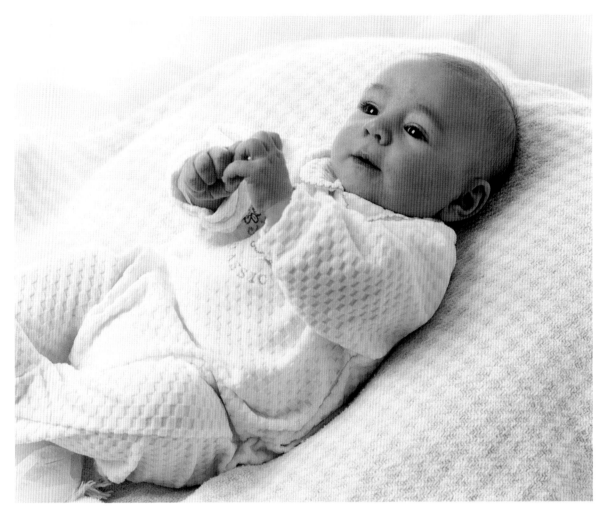

ABOVE: Notice how the weave in the blanket matches the weave in the baby's outfit. Good planning results in memorable portraits. The baby's hands, held together, help keep your eyes on his face.

OPPOSITE: Keeping everything in one color helps intensify the baby's skin color. The pillow under her head helps to hold her steady and in a comfortable position.

When photographing infants, a baby pillow that is designed to prop the baby up is an invaluable tool. This prevents them from sliding down into a position that makes their faces fall to their chins. This can make them look rounder than they are. These pillows can be draped with soft fabrics that match the baby's skin tones or clothing. Coordinating these two elements creates a portrait that is pleasing to the eye.

At this young age, a baby will respond to the sound of a rattle. The trick to getting his attention is not to start shaking the rattle in front of his face. Shake the rattle near the ear you want him to turn to. If you shake it by the left ear, he will turn to that sound and then you can have him focus on the rattle in front of his face. The sound of Mom's voice

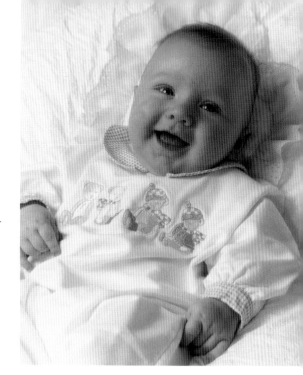

RIGHT: No doubt about this being a boy! Photographing from an angle looking down at him will feel natural for the parents who see him in this position often. It's also a natural for him to be looking up and smiling from this angle.

BELOW: Bring the camera even with the baby's eyes and you will capture the sparkles reflected from your lights and reflector.

OPPOSITE: Sometimes, babies need some help to prop them up and be stable. A round pillow under one arm will provide the support required for them to push up their heads.

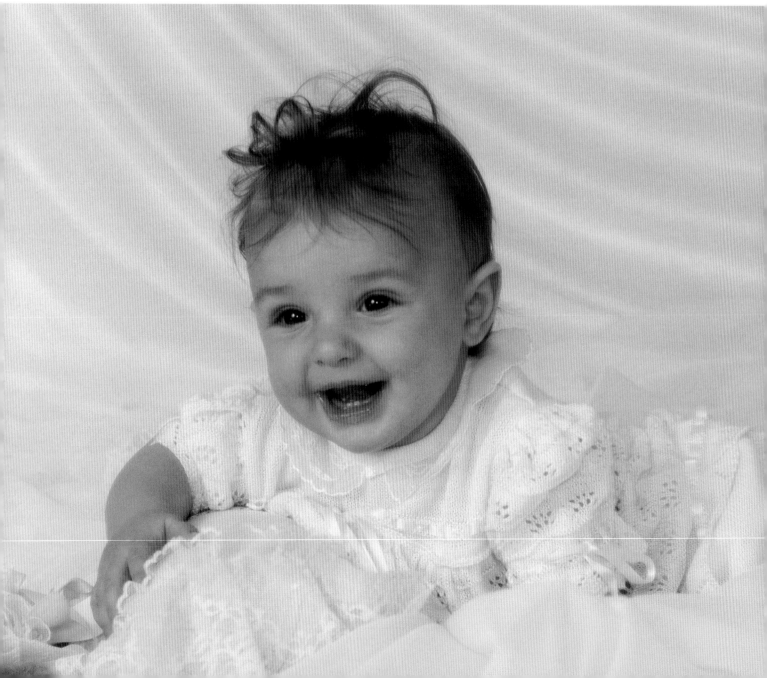

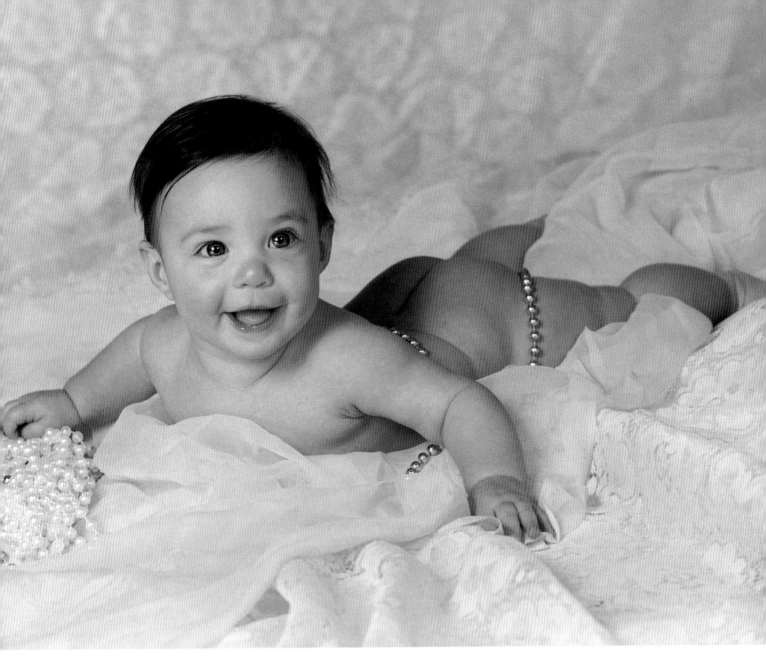

will also cause the baby to smile. Be sure to have Mom at least 24" away from the baby's face. Otherwise, he won't be able to focus. Remember, infants cannot focus on anything that is too close or too far away.

At approximately four months, a baby will lift his head high when placed on his tummy. This pose can yield charming nude portraits. Watch for babies that roll over early, though. Keep Mom or an assistant nearby at all times so someone can jump in and gently move a wiggly baby back into position. A small pillow

SOMEONE CAN JUMP IN AND GENTLY MOVE A WIGGLY BABY BACK INTO POSITION.

under babies' chests can help them pick up their heads better. Also, be sure to watch that their little arms don't get caught under their bodies. Gently bring the baby's arms out from under his body and put his hands in front of him so he can put pressure on his hands and lift himself up easily.

At the age of five to six months, a baby will either begin sitting up in a propped position or sitting up by himself. This begins a particularly easy age to photograph infants. At this developmental stage, it is most important you are prepared with a plan as to how you will be photographing the baby. This will allow you to move through the sets and props quickly and efficiently. While babies at this age are charming and interested in everything, their moods

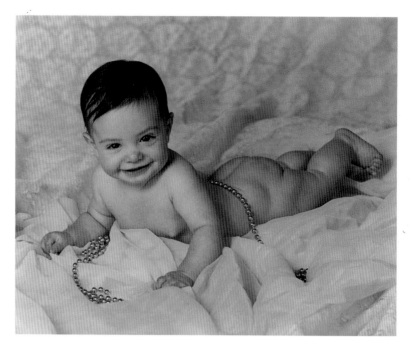

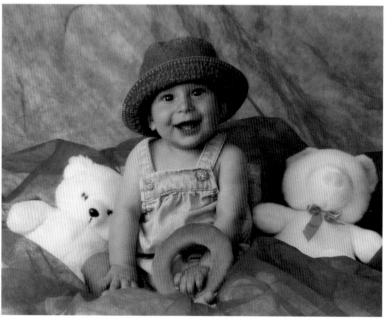

TOP: This little girl has a mischievous smile made all the more charming by the pearls on her backside. A firm base under the background gives her the support she needs to push herself up.

BOTTOM: Five to eight month olds will almost be sitting up themselves, and are sweetest when their faces stand out from the portrait. Keeping the portrait in an even key all around him makes this little guy's smiling face the first thing you see.

OPPOSITE: Sometimes the simplest of props is best. This baby's mom brought her own chair and blanket and the baby naturally went to pull up on it. Calling her name made her turn around at just the right moment.

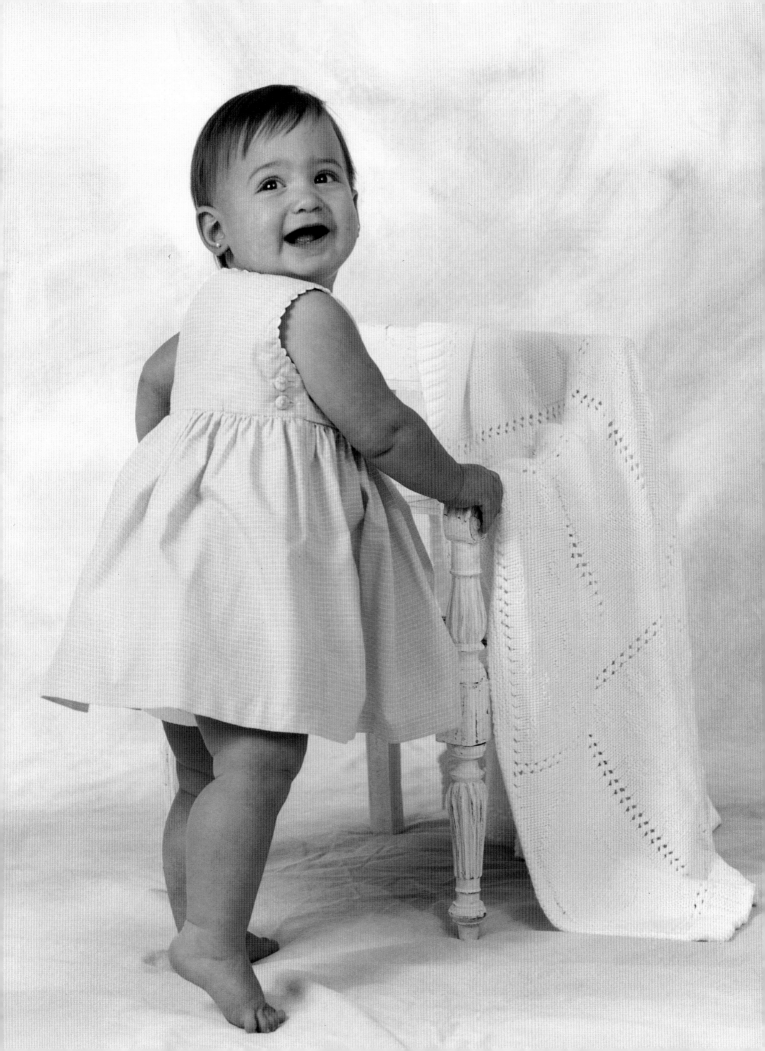

can also take sudden turns for the worse. Instantly, they can become tired and hungry. Don't over-plan for this age. Expect to photograph (at the most) three different settings or clothing changes, and move through them rapidly. Having small feathers to tickle the baby's arms, legs and under his chin will help get charming expressions.

■ *Seven Months to Thirteen Months*

This age starts out easy. At seven months, a baby is sitting up and can hold items and reach for them. Sitting the baby down with preplanned items or on a special set works nicely. Beads are particularly interesting to a baby. Yes, they will put them in their mouths—so be sure they are clean. Be ready to pull the hands with the beads down from the baby's face and capture that magical expression. Hats are also great props for this age group. Floral or straw hats look wonderful

Things don't always go as planned. These twins each had a different idea of what makes a great portrait.

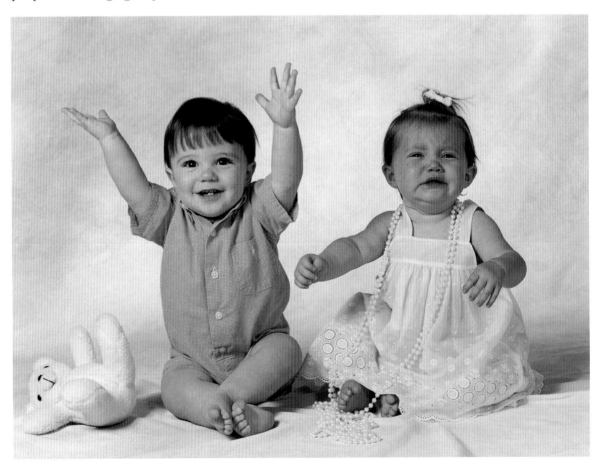

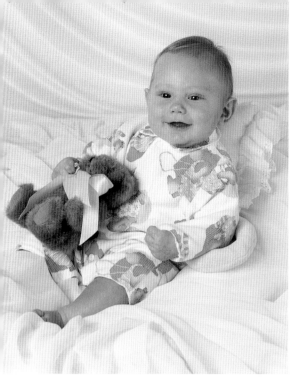

LEFT: The props for this simple portrait match the baby's outfit exactly in colors. It all ties in together and there is no distraction from that adorable face.

BELOW: A delightful mess for a first birthday portrait! Notice the mirror on the floor. This added more color to the portrait by reflecting the cake and giving the floor a soft watercolor feeling.

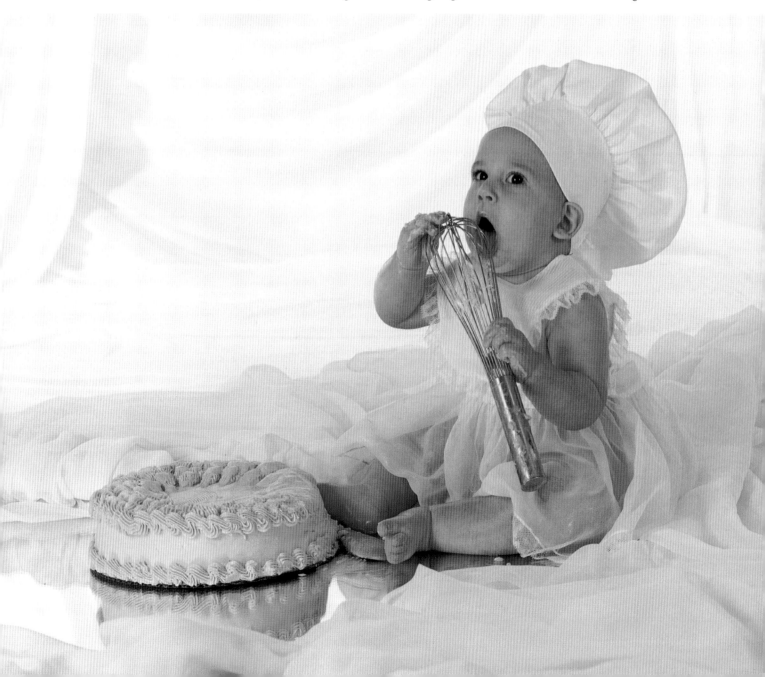

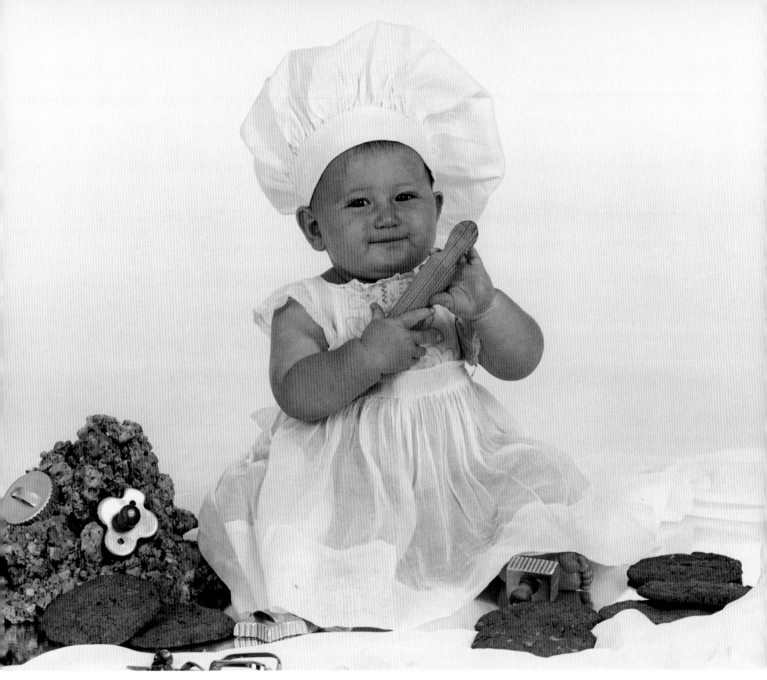

on girls, and baseballs caps or sailor hats are charming on boys. The hat helps to frame the child's face and adds an effect of hair that most children do not yet have at this age.

Eight months is also when babies start to clap hands and play pat-a-cake. They love to imitate whatever you are doing. Give them a stuffed animal and hold one yourself and show them how to hug the toy—many times they will imitate you with the one in their arms.

By around ten months, babies are standing up while holding on to a support. A good solid chair or ladder is excellent

This is one smart cookie—and with her cookie dough and rolling pin, this one year old makes a pretty picture.

for this. While they are not walking yet, you can use their relative immobility to your advantage to keep the baby in one place and get great expressions. Babies of this age are also interested in things they can pick up with their fingers. Put a few pieces of fake fruit or little cars on a ladder or chair, direct the baby's attention to them and the automatic reaction is to reach for the items.

Another method to capture expressions for this age is to sing songs to them that they are familiar with. The best songs are ones that will encourage the baby to clap hands or bring their hands together. These portraits are delightful as they show the baby's developmental progress and ability to interact.

Games of peek-a-boo still work great for this age, also. Hiding just behind your camera and popping your head up will delight baby and reward you with great expressions. At this age, babies also like to see Mommy or Daddy doing silly things. Utilize Mommy by having her stand next to the camera (be sure she is standing up and not crouching down to baby's level). This keeps the baby's eyes up and gives more color and shape to their eyes.

AT THIS AGE, BABIES ALSO LIKE TO SEE MOMMY OR DADDY DOING SILLY THINGS.

Fourteen Months to Eighteen Months

Watch out! This age is one of the most difficult to document. Babies are walking, talking and expanding their independence. To ground babies of this age, a game of rolling the ball back and forth with Mom is good. At this age, some babies will respond well to directions. Try asking them to sit down or climb the ladder. Portraits of a toddler climbing into a chair are charming. Their usual method is to put a knee on the chair first and lift themselves up and then turn around. Don't help them, but keep Mom in place just off-camera to help if they get tangled or frustrated.

The tickle feather works especially well at this age. It's important to remember *never* to put the feather into the

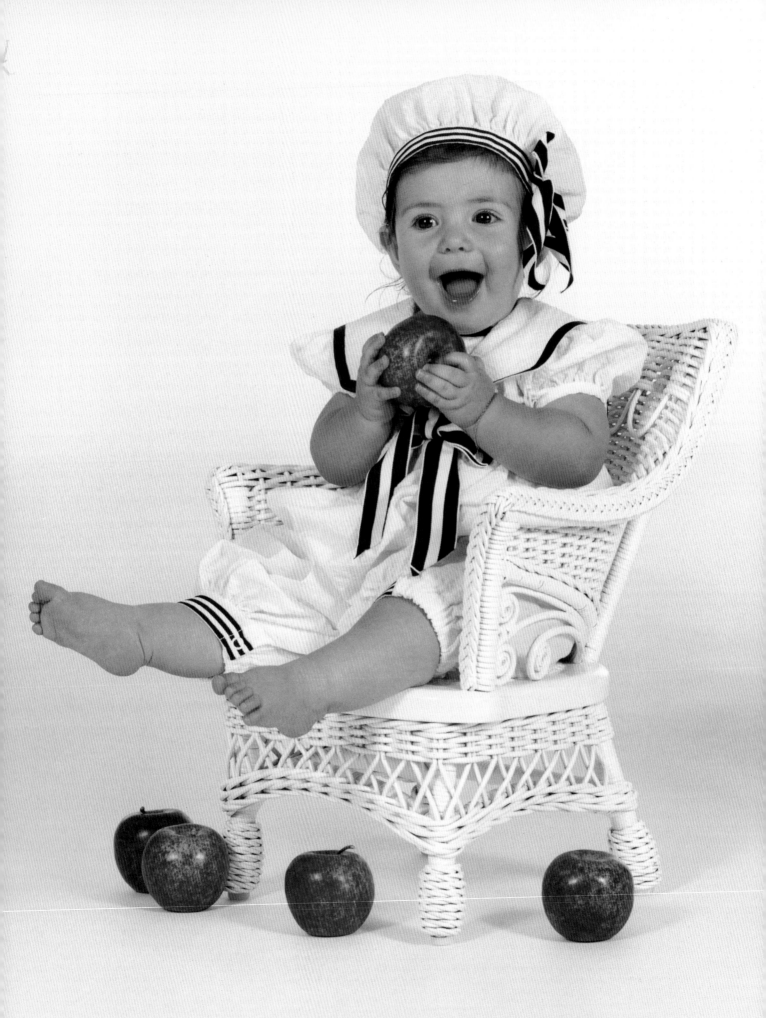

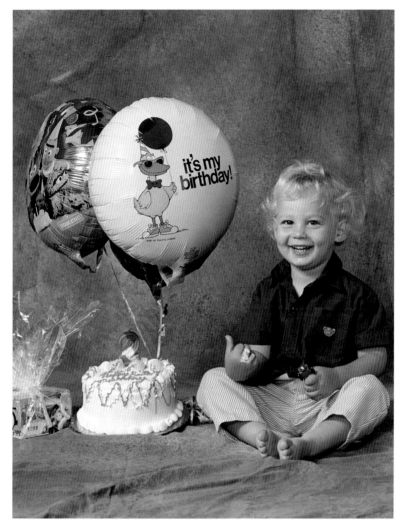

ABOVE: Birthdays are great photo opportunities to use a real cake and let the fun begin. A few balloons tell the story of why he looks so happy.

OPPOSITE: What could be simpler than a baby, a chair and some apples? Add the stylish hat plus a cute expression, and this simply-lit portrait is a winner.

baby's face first. Tickle their feet, arms or Mommy first. Then, lastly, tickle under the baby's chin or on the baby's cheek. Be gentle and reinforce the fun of it by saying the words "Tickle, tickle!"—words familiar to them as part of play. Your expression and demeanor will tell the baby that this is a fun time and not to worry about anything.

Portraits of babies walking at this age are great. Usually, when babies walk they have the gait of a monster with both hands out as they fall heavily from one foot to the other. This is unforgettable on film! You can have them walk to Mommy, then go back to the chair and sit down and do it again. At this age, you can repeat this process about four or five times before they get bored with the whole game.

Nineteen Months to Three Years

While this age is a challenge, the children can also be the easiest to distract. The young ones are talking and responsive. They like many different objects to distract them. Put a penny in their hand and have them hide it—or have them put it in a pocket. Delightful portraits can be created while

the child finds his pocket and opens it and puts the penny in it, and then has a great expression of accomplishment.

Children also love riding toys at this age. The trick is to put a flat wood bar under the wheels on the side of the toy that is away from the camera—then the wheels won't move. Rocking horses, little cars, tricycles and other riding toys will help keep the child in one spot so you can capture great expressions. Look in toy stores and unique children's gift shops to find the most unusual toys.

■ Four Years to Six Years

Have fun! At this age, kids will make you laugh and will generally play with you. Four to six year olds are little people who walk, talk and have their good and bad days. On a good day, they will sing songs for you or with you. They will tell you about their pets at home or about their new baby brother. On a bad day, they will pout and just continue to say "no" to anything you do with them. Appealing to their sense of humor can many times turn around the bad days. Try letting them cling to Mom if they want. Tickle their toes. Try making funny faces and being a clown. In general, be silly and wait them out. They won't normally stay in the bad mood forever. (If, by chance, at any age you find a child is truly adamant about not being cooperative, check for a fever. Often, a new mom doesn't even realize the child is sick. Young babies often run fevers due to teething. In these cases, it is best to reschedule portraits for a day when the child is feeling better.)

APPEALING TO THEIR SENSE OF HUMOR CAN MANY TIMES TURN AROUND THE BAD DAYS.

This age is also a good time to invite the outgoing child to sing songs to you. As always, be prepared to capture the moment when the child is lost in song and forgets that the camera is there. On the flip side is the shy child who won't talk at all at this age. It is best to do all the talking when interacting with this child—it takes the pressure off him. Quietly, ask Mom for the name of the child's pet or his best

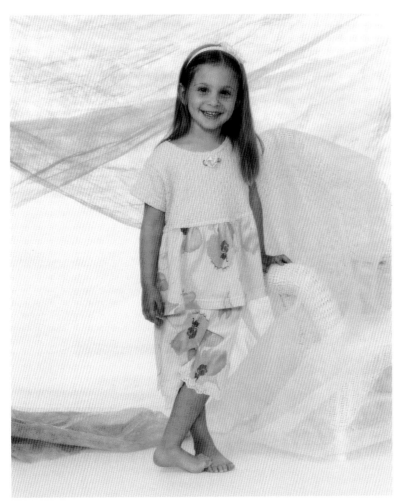

Her feet may look odd to you, but this is a natural stance for a little girl. Lots of soft fabrics help keep the focus on her—not on the props.

playmate. Then, use the information to carry on a somewhat one-sided conversation. The child may not crack into a huge smile, but his recognition of the names and your extensive knowledge of his life will create good expressions.

■ Older Sibling Syndrome

A new baby at home throws the older child(ren) into a new place in the family. Be prepared for a mom who desperately wants a portrait of the new baby (usually not sitting up yet) and the older sibling together. While at home, the big brother or sister will hold the baby wonderfully—but the moment you need them to do it in the camera room they will essentially pretend their arms are limp and far too weak to hold the baby.

The best way to handle this is to sit the older sibling in a child-sized chair with a back. Get him comfortable, then sit the baby in his lap, leaning the infant against the sibling's body. Use pillows to help prop the baby in the right spot. This way, the older child is not 100 percent responsible for holding the baby and it takes the pressure off them.

Ignore any inappropriate behavior from the older child and do not tell him/her to be the "big brother" or "big sister." Instead, emphasize how wonderful he looks, and how great he is to give you such smiles. Keep the child's thoughts on himself or herself—not on the new baby.

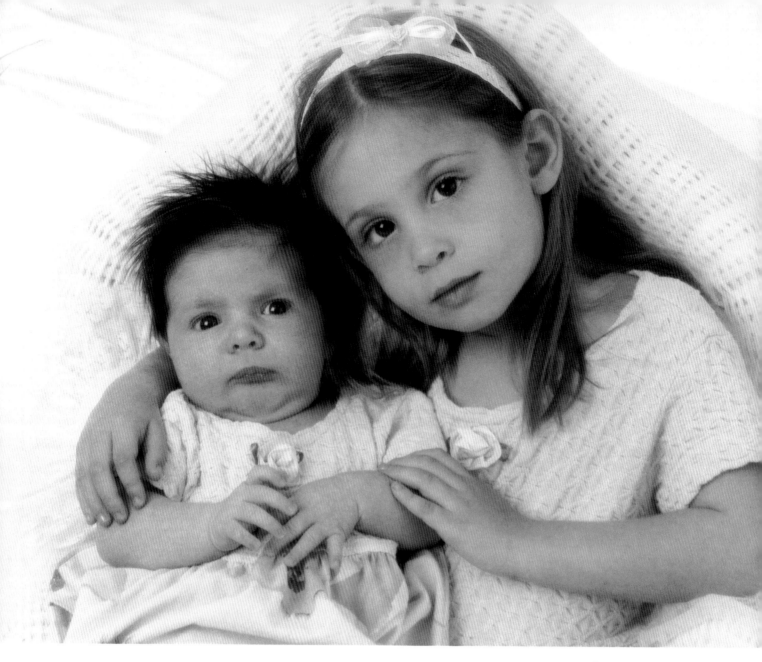

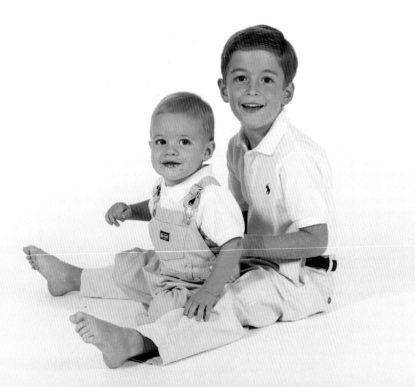

ABOVE: A most memorable portrait of the big sister protecting and loving her little sister. Gentle expressions have their place in portraits like this one. This girls were posed in a chair that had high arms to help support the big sister's arm as she held the baby.

LEFT: Sometimes the best portraits are those that are kept simple, placing all the emphasis on the expressions.

OPPOSITE: This was a natural moment between the sisters, and one that really tells a story about their relationship.

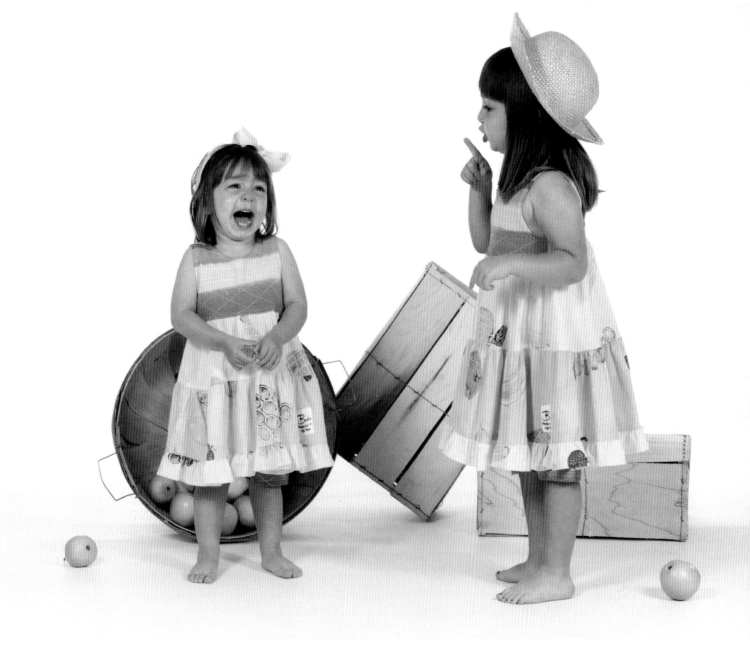

Another pose that seems to work for a sibling portrait is to lay both children on the floor with the older child's arm over the baby's back. This brings the children's heads close together. Next, create a diversion in order to get the baby to pick his head up and the portrait is done. For another pose, lay the older child on his back and put the baby on his back in the crook of his arm. Shoot from a high angle pointing down at them. Again, a beautiful portrait is created with less pressure on the older sibling to hold the baby.

LAY BOTH CHILDREN ON THE FLOOR WITH THE OLDER CHILD'S ARM OVER THE BABY'S BACK.

A Word about Moms

You will encounter many different moms when you photograph children. The basic idea (no matter what the mom's personality) is to gain control of the situation. *Don't* let her bribe the children or make promises she can't keep. Give her a chair near the camera and ask her to let you talk to the children. If necessary, you can incorporate her into routines to help create smiles.

Having Mom next to you at the camera and tickling her with a feather will not only give her a job to do, but also a reason to smile at her children. After tickling Mom with the feather, you or she can tickle the child(ren) with it. Remember, you should always tickle the feet or hands first, not the face.

Keep in mind, moms mean well. They are trying to get the kids to cooperate and make your job easier. It is best to keep mom in the camera room, but be sure she knows you are the director. The worst scenario occurs when the mom, dad and grandparents are *all* at the camera yelling at the kids to get their attention. It is simply too much for a child to absorb. Either choose one parent to help, or do it yourself. Dads are perfect foils. They are usually the tickle-monsters in the house and the ones children associate the most with fun and silly games. Tickling dad or using him to help create smiles usually works well with the two to six year old.

REMEMBER, YOU SHOULD ALWAYS TICKLE THE FEET OR HANDS FIRST, NOT THE FACE.

Conclusion

Overall, no matter what age child you are photographing, be prepared before going into the camera room, and have a game plan for accomplishing your goals. This will make your job easier and insure that the parents see you as in control and creative. Your greatest assets are allowing enough time so that the session is not rushed, and creating a relaxed atmosphere by having a tremendous amount of patience.

RIGHT: Simple and serious. This combination creates a beautiful portrait.

BELOW: A cool-looking guy with his motorcycle makes for a stylish and serious portrait. Unique props help your portraits to be special for clients.

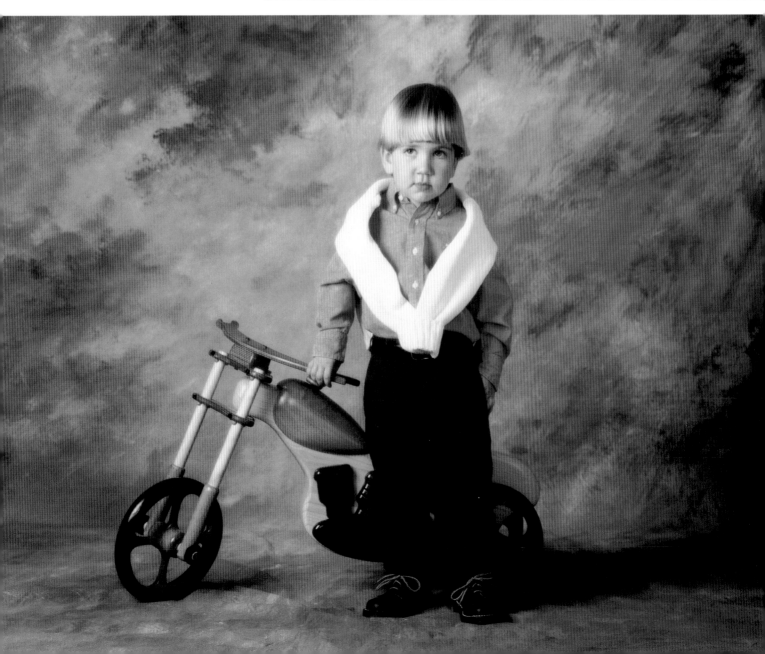

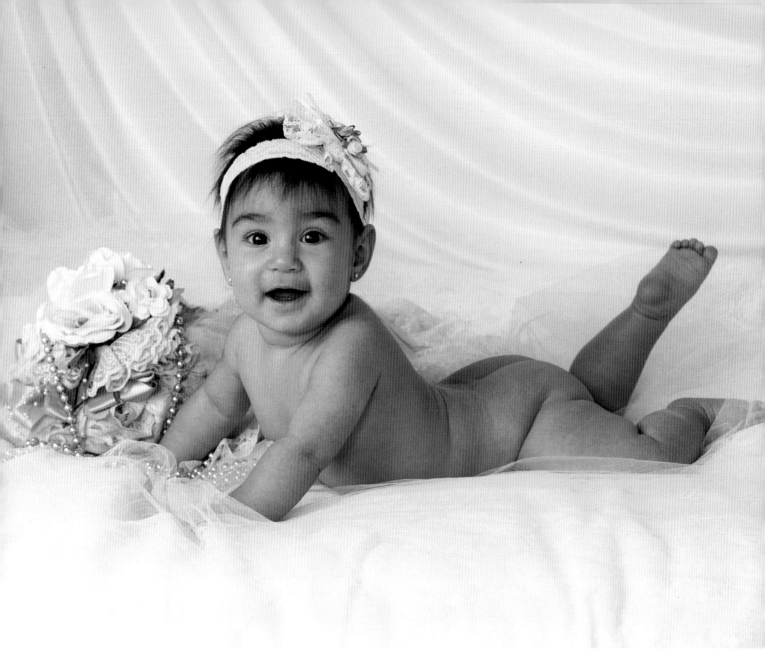

ABOVE: Babies will do the natural thing. Wait for them to react to you and the result will be a charming portrait.

RIGHT: All the props in this portrait were chosen to color coordinate, as well as to keep her interest. For this active little girl, we needed to distract her with props. The long colorful string of pearls are easily found in Christmas ornament stores.

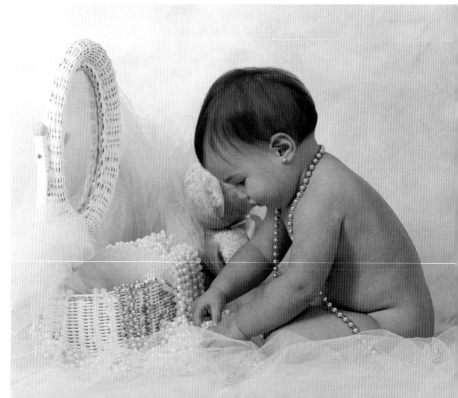

A TYPICAL PORTRAIT SITTING

All successful portrait sittings start with good planning. The better the planning, the less is left up to chance. There are enough surprises in a portrait day without adding to them with poor preparation.

Clothing Consultation

First and foremost in your planning is a clothing consultation. Whether the consult is done in person, by phone or fax, Internet web site or brochure mailed to the client, it is imperative that the subject is discussed. Misconceptions about the portrait session often start with the wrong clothing selection for what would otherwise be the right portrait.

If possible, it is best to have a face-to-face portrait consultation with the client. Let them see your photography and see how different clothing works different ways. When you sit and actually look at a print, it is very easy to see how distracting clothing with insignias, logos and bright stripes can be. Not everyone is visually-oriented, and the proof of that is that some clients will still show up with the wrong clothing even after a visually-oriented, one-hour clothing consultation.

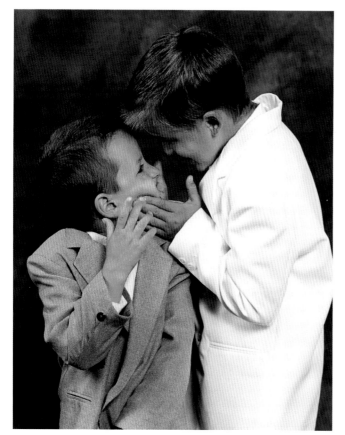

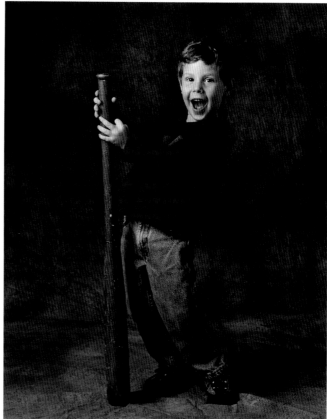

TOP LEFT: Brothers being silly seem twice as interesting dressed in their best clothes.

TOP RIGHT: A boy and a baseball bat—what could be more classic? The trick is to have a plain solid bat that has no logos on it to distract from the child's expression. The dark background guides your eye to his face.

LEFT: Twin boys dressed alike don't need much else in their portrait. The little cars they are holding were enough to keep them busy and happy.

OPPOSITE: Place your subjects, then work on great expressions—it will result in awesome images! The shirts on these boys were all wrong, so I decided to go with a different look. As a result, the faces are the first thing you see.

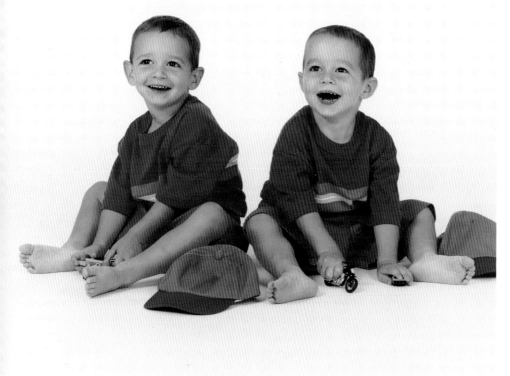

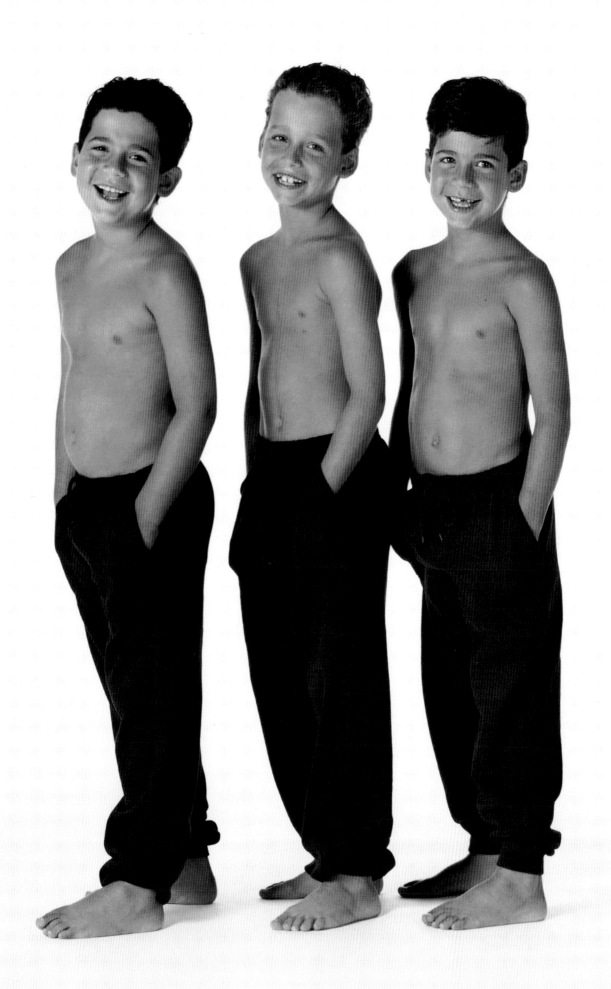

Another way to do the clothing consult is to have a web site on the Internet that has a page about nothing but clothing options. This information can be invaluable for clients who are unable to get to your studio long before their portrait session. As soon as they schedule their appointments, they can log on to the Internet and see the clothing web site page.

If all else fails—at the very least—fax or mail a brochure about clothing options to the client. Mail it immediately after they book the appointment. Follow up a few days later with a call to be sure it was received and read.

Coordinated clothing with simple props creates a sisterly portrait.

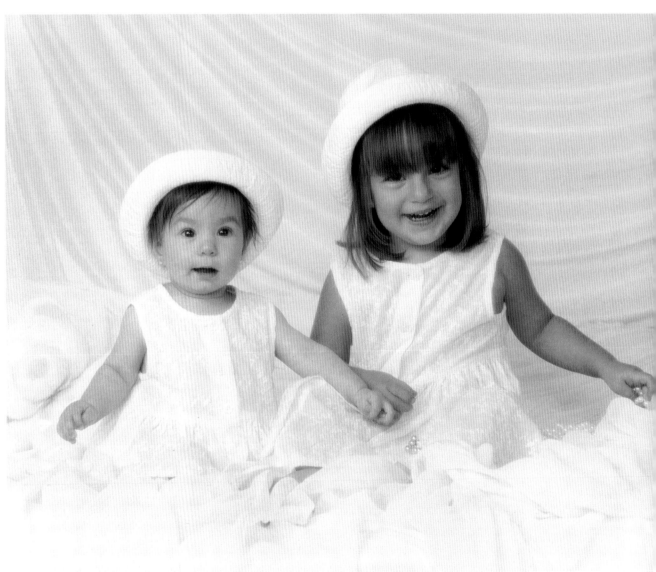

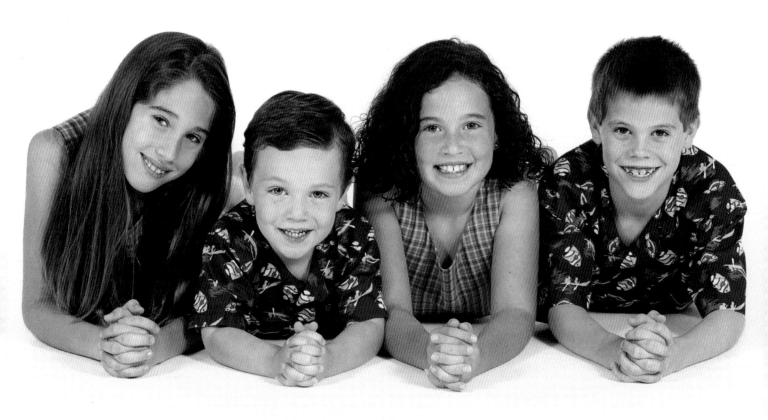

While the clothing in this portrait is not totally coordinated, it is downplayed by incorporating an original pose that is a welcome change from the traditional head and shoulders close-up portrait.

The same basic portrait can be done with two very different expressions. The solid clothing lets the eye concentrate on the little girl's face. Her changing facial expressions create totally different moods in each portrait.

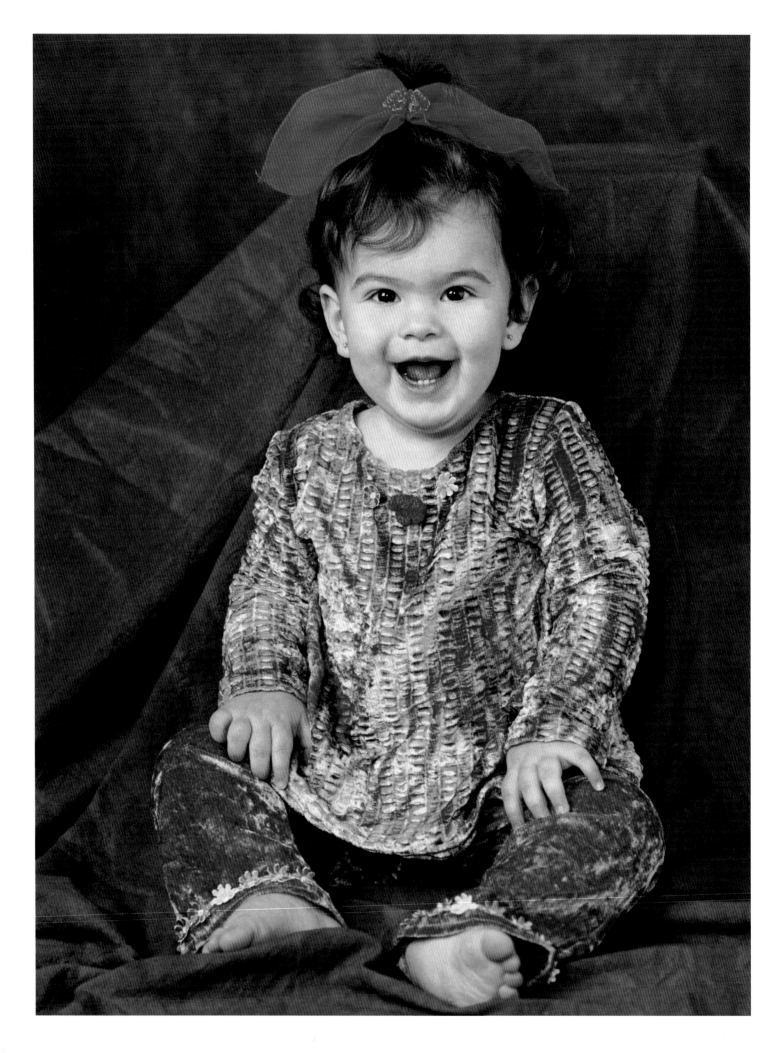

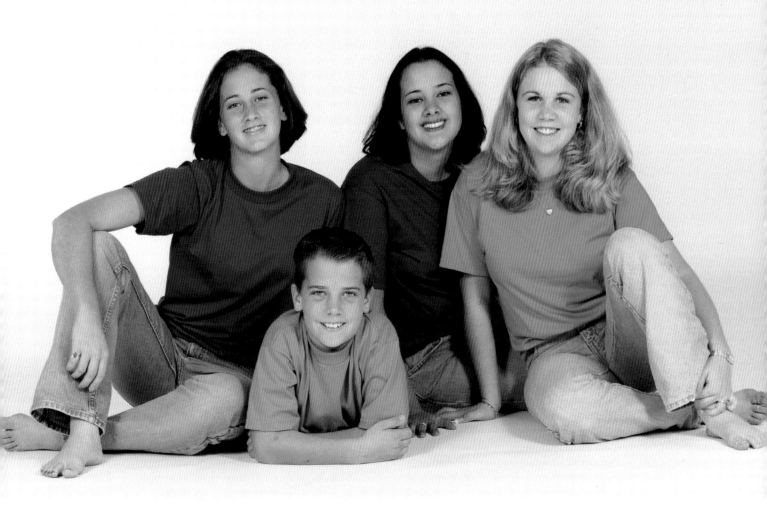

OPPOSITE: A background in key with the subject's clothing helps keep the focus on her face.

ABOVE: Simple is sometimes best. Three older sisters surround this lucky brother. Different colored T-shirts add a little variety to this fresh sibling portrait.

■ How Many Outfits? How Many Backgrounds?

The first decision to make is how many clothing changes there will be. Nothing is more daunting to a photographer than having a client show up with six outfits for a six month old. Often, the mom then proceeds to explain why each outfit is not only special and meaningful, but also that she wants different backgrounds with each outfit. Whew! That can be the beginning of a *nightmare*.

In almost all portrait sessions, it is best not to plan to photograph more than three different outfits or backgrounds. Doing more will only serve to tire the children, exhaust you and create confusion when it's time for the client to choose the portraits. Besides, like show business, it's always good to leave the client wanting more.

Portraits of babies should be limited to nude portraits and the *possibility* of two outfits. I say "possibility" because you must be sure the mom understands that the portrait session will only last as long as her baby is enjoying it. The session ends when baby's patience ends, *not* when all the outfits have been photographed. Remember, the objective is to show the *subject* of the portrait, not the clothing.

BELOW: Simple props and backgrounds let the relationship between the children be the focus of the portrait. This portrait shows the true emotions of the older siblings.

FACING PAGE: The addition of one strong pastel prop is enough to make this the perfect baby portrait. The pink in the bear is carried through in the baby's skin tones.

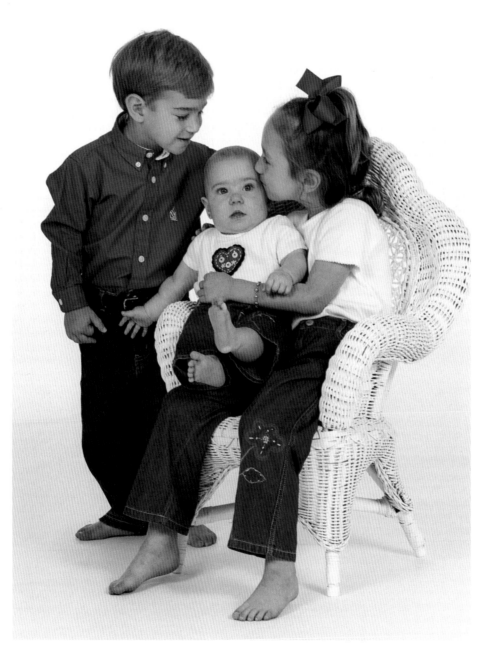

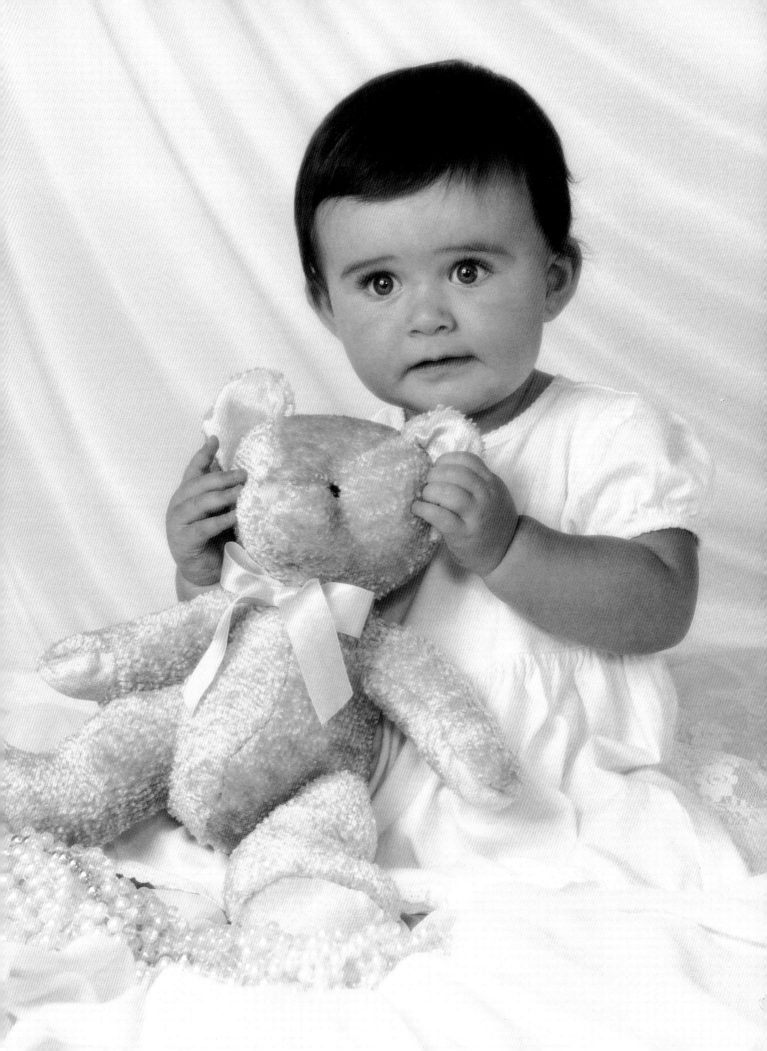

LEFT: Slicked-back hair can really enhance beautiful cherubic faces. This one is a classic look, which can also be done with younger babies.

OPPOSITE: It doesn't take much to make an older girl look elegant; just give her a simple pose and let her be herself. Simple clothes and an uncluttered set let her face tell the story.

◼ Clothing Selection

Babies look best in clothes that are not fussy or stiff. Little girls who are only a few months old get lost in stiff dresses with collars. Usually, the dress ends up getting pulled into her mouth and then it's ruined. Form-fitting cotton clothes in soft pastels and white look best on baby. The softest and simplest clothing works best for newborns to five month olds. If the feet are going to show, absolutely *do not* put socks and shoes on the baby. Among the most lovable and endearing body parts on babies are their little feet and toes, and their little chubby thighs and arms. That's what makes a baby portrait soft and huggable.

Clothing with huge cartoon characters on the front is very distracting. Even small logos can become the focus of a portrait. Be sure to be clear about what is expected from the clothing. A good way to bring this point home is to photograph someone in clothing that is obviously wrong and then in the right clothing. During the clothing consultation, show this sample and the point should hit home.

For older children, many of the same rules apply. Simple clothing that fits well and blends into the portrait will look

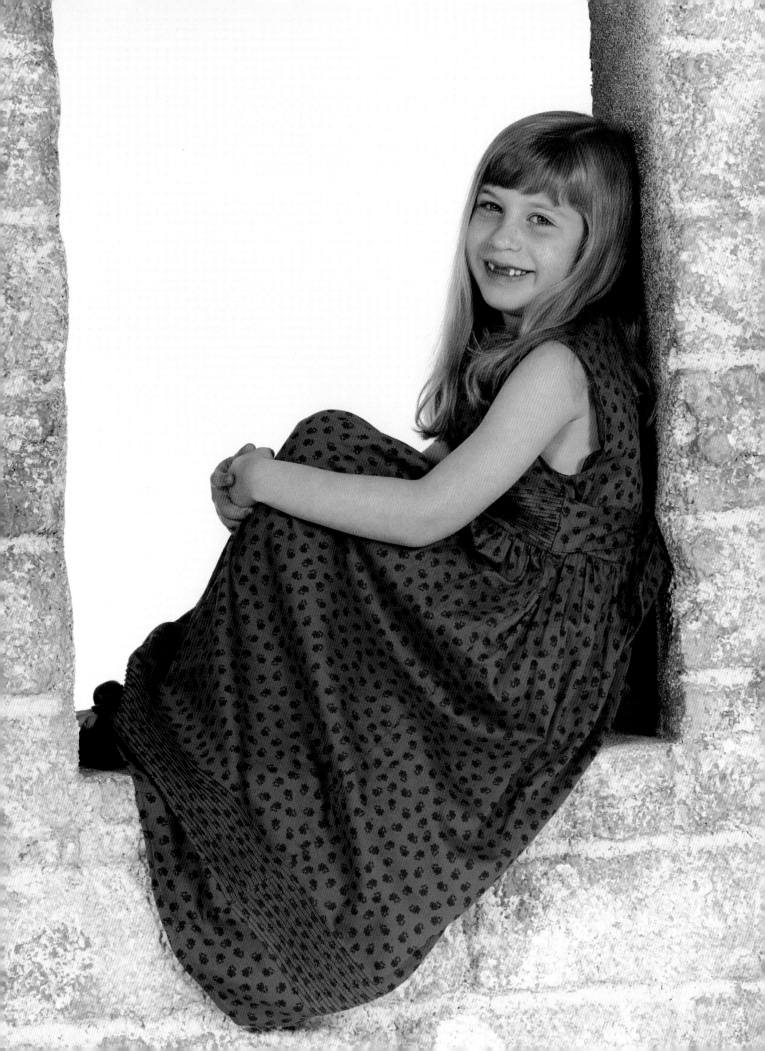

best. Denim is the number one choice of clothing for portraits. The reason is simple: denim is timeless. I defy anyone to tell what year a family portrait was photographed if everyone is wearing denim. Other than the hairstyles and make-up, it's hard to tell. Denim doesn't "date" the portrait the way bell bottoms and miniskirts do.

While It may be cute to dress twins in matching clothing, it's also great to dress them similarly and let the drama be the matching faces. A prop they can grab and climb on helps keep their attention.

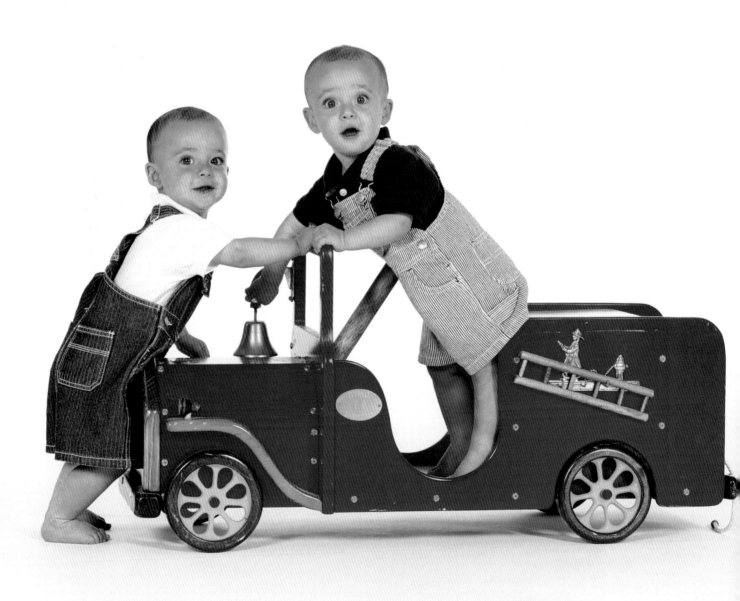

◼ *Clothing Selection for Black & White Film*

Black & white film is great for showing textures. Lace, cable knit sweaters, terry cloth, soft angora, corduroy and other fabrics such as these will add a third dimension to the portrait by showing texture in the film. In black & white it is just as important (if not more so) that the clothing be as simple as possible. The only rule that can be broken is that the colors can be complementary—in the same "tone," but not necessarily in the same color. Pastel pink, pastel blue and lilac will all photograph with the same tonal level in black & white. Do not mix white with colors, however. White is very difficult to photograph with detail on black & white film. If the client wants to wear smooth white fabric instead of a textured one, be sure everyone in the portrait is wearing the same thing. Otherwise the smooth white clothing will steal the scene by having the brightest highlights.

WHITE IS VERY DIFFICULT TO PHOTOGRAPH WITH DETAIL ON BLACK & WHITE FILM.

◼ *Photography Day*

When the client arrives with the children, a bond needs to be formed to let the children know this is going to be fun. We get down on the floor and play with them, using some of the toys in the front room. At this time, it's not our objective to get the children to laugh or smile—only to get them to relate and understand that we are people they are going to enjoy interacting with.

Clothing Evaluation. A typical photography session starts with the clients arriving and showing us the clothing they have selected. After final decisions are made as to what outfits will be photographed, the client goes into the dressing room to change the children.

Setup. At this time, the backgrounds that have been chosen are set up and the props to be used are placed out where they are handy to reach. It is important that the props used to elicit smiles are easy to get to, but not within

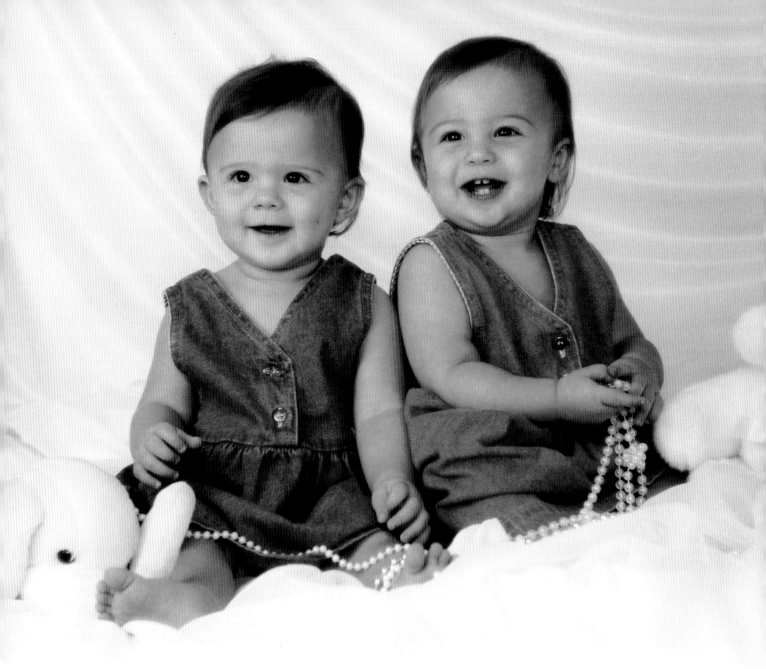

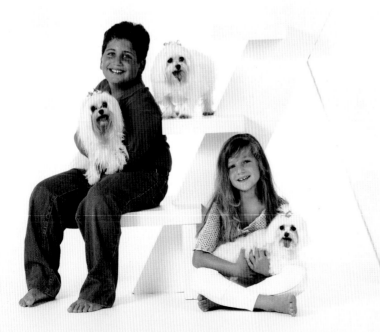

ABOVE: These twins are individuals, but with their shoulders touching they are also connected. Keep twins close if possible.

LEFT: Children alone provide a challenge, but how about adding three small dogs? Use some whistles and squeaky toys to get all the dogs to look at the camera at the same time. We knew the dogs were to be part of the portrait because it was discussed during our consultation.

FACING PAGE: Ask outgoing children to perform for you. This little girl needed no props—just a little encouragement. She sang and danced her way through the session. A muslin background helped keep the image soft.

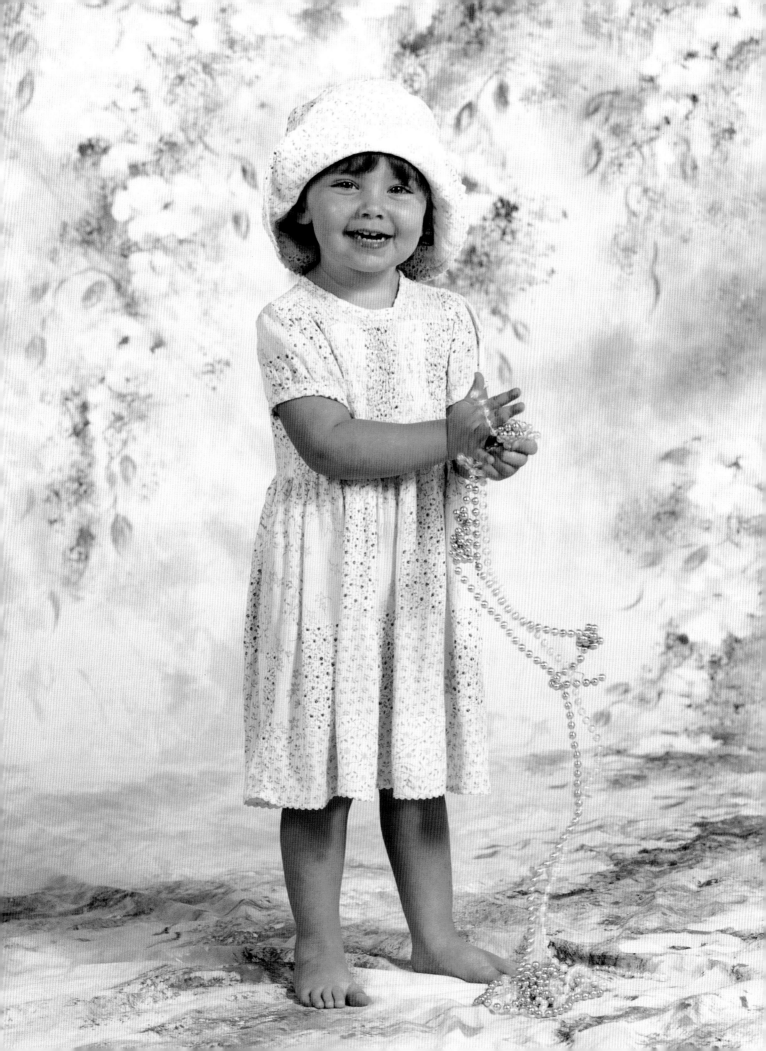

the children's eyesight or reach. That means the Mickey Mouse, the "tickle feather," the musical camera, rattle and other novelties should be near the camera but not in plain view.

Full-Length Portraits. Usually, the photography begins with full-length portraits. This way the child doesn't feel crowded with you on top of him doing close-ups; this gives you an opportunity to relate and bond with the child before getting too close. It also gives room for Mom or Dad to be in full view and not hidden by the photographer, lights or reflectors. A particularly frightened child may even need Mom to sit on the set with him just out of camera view.

Close-ups. The last segment to be photographed is the close-ups. By that point, the child will know you and not feel threatened when you get closer to him with the camera and

Close-ups are always popular. Be sure your lighting is even across all the children's faces. Meter it from one end to the other.

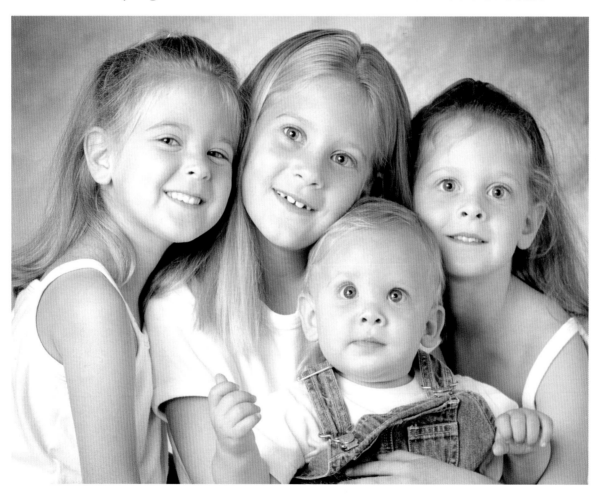

lights. Hopefully, you will also have worn the child's energy down a little, making it possible for him to sit in one place on a ladder or chair with less fidgeting and more attention.

All told, a typical sitting might consist of two different backgrounds with two or three clothing changes and a variety of props and poses including full-length, three-quarter and close-up.

▢ *Final Viewing Appointment*

At the end of the session, we go out front to the reception room with the client and schedule an appointment to see the images at the studio in a few days. At that time, we also give the child stickers. Children love stickers and they give us an easy and inexpensive way to have the children take home a memento of their experience.

These are simple props with the chair being in color key with the darker background. The child's outfit blends perfectly in color and lets her stand out as the main subject.

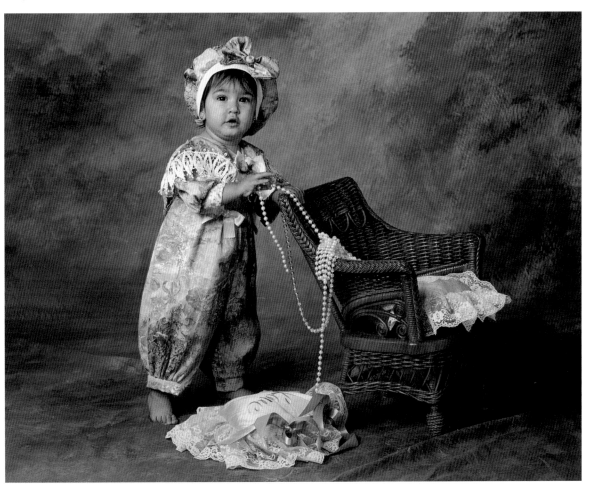

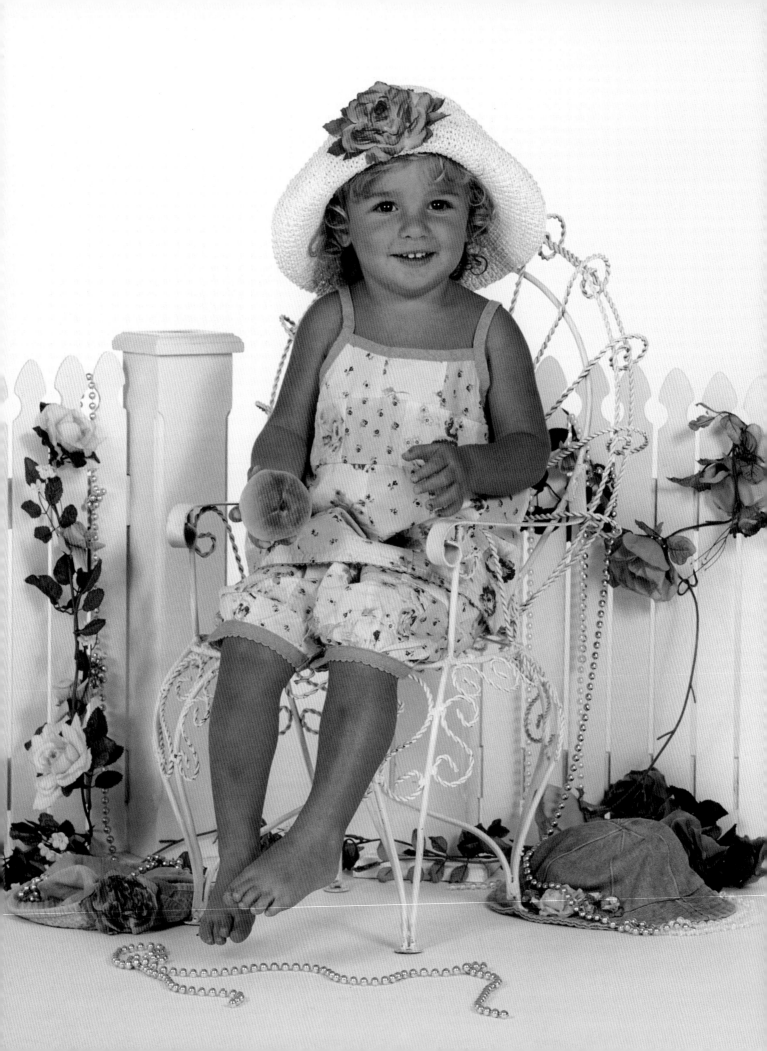

One or two days before the viewing appointment, call the client to confirm. Never *assume* they will remember. In one night, things can change tremendously for a family. All appointments need to be confirmed so that your studio time will not be wasted and the clients won't be disappointed.

■ Conclusion

Finally, sit down for two minutes. Relax and review the session. How did it go? Can something be changed with the next session to help it go more smoothly? Was there a prop that worked especially well? Was there a new pose that looked particularly good? Spending these few minutes clarifying your thoughts will help improve your next session, and will also fire up your creativity for future portraits.

OPPOSITE: Some children need a place to sit no matter how many props you give them. Know when to add that chair to make the child feel secure and comfortable. Have chairs in the studio that are light and airy that won't be too conspicuous.

RIGHT: How the background is lit and how far away the subject is from the background can change the entire portrait. This child is farther away from the background to let it go out of focus behind her and the background is lit to be very pastel to match her dress.

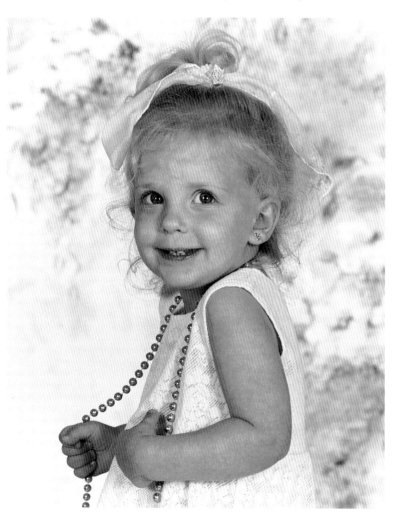

CHAPTER 4
EQUIPMENT: WHAT YOU REALLY NEED

It's exciting to walk into a studio and see all the lights, stands, cameras, filters, backgrounds, reflectors and various other exceptional equipment that can be used for portrait photography. But it's also a luxury to own all of these items. To be a good—no, *great*—portrait photographer it's not necessary to own quite that much equipment.

There are a few levels of equipment necessities and each will broaden your ability to create different effects and lighting for your subjects.

◼ *Camera and Lens*

One of the wonderful advantages in making baby and children's portraits is that it's not necessary to have every fancy and intricate piece of equipment to start out. It can be done with minimal equipment.

Obviously, first and foremost you need a camera. Whether it is 35mm or medium format model, the most important part is the lens. If starting out with a 35mm camera, it is essential to have at least a 85mm to 105mm lens. These are known as portrait lenses and create the best

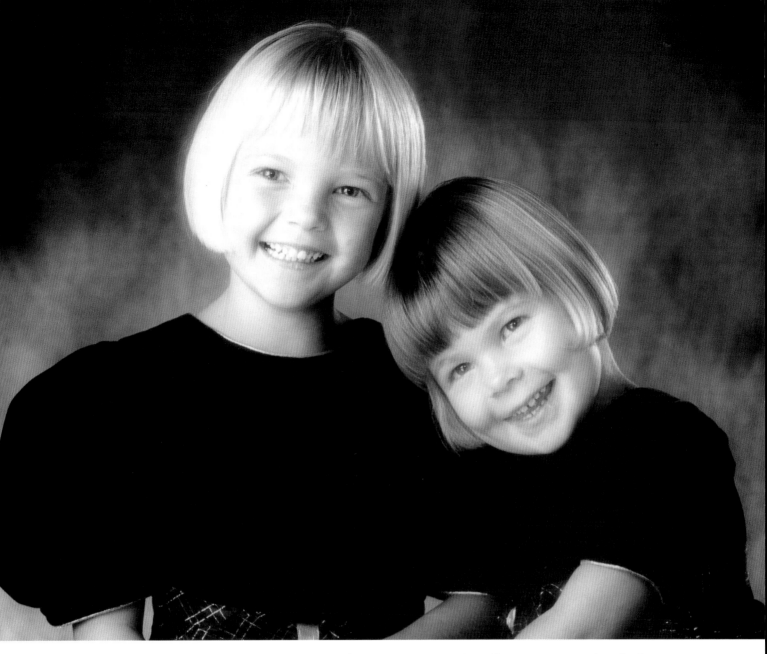

Two little girls in black velvet dresses photographed on black & white film using a 150mm lens at f/8.0. Add the dynamic expressions and a classic portrait has been created.

close-ups of children. They also allow you to work a little farther away from the child, permitting a certain freedom of composition and giving the child space to move around in. It is essential to be working at apertures of at least f/8.0 if the child (who will never stay perfectly still) is to be in focus. For a medium format camera, the lens of choice is a 150mm. Full-lengths to close-ups can be done with this one lens. I can honestly say that in this book, 98 percent of the portraits were taken with a 150mm lens. It's clear that it has the flexibility to create both full lengths and various effects—right up to the tightest close-ups.

Cropping and Enlargements

When working with 35mm it is important to learn how a 35mm negatives crops when ordered in different sizes. An 8"x10" print from a 35mm negative loses much of its space on the sides. But when printing a 5"x7" from a 35mm negative, it is a perfect fit. The total image area is used. Because of this, when photographing there is a need to crop in camera and leave space for larger prints to be cropped.

On the other hand, a 2¹/₄" square format permits you to create either square or vertical/horizontal prints from the same negative. With children, this flexibility is terrific. Many times, your image can be composed in the camera to permit all three looks from the same negative. A square negative also leaves space for the child to move around the set somewhat and still be in the camera frame.

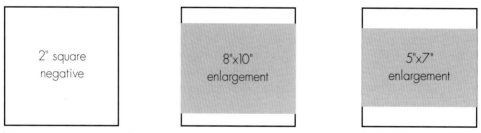

With an 8"x10" enlargement, cropping occurs at the edges of the frame. If you will enlarge to this size, frame the shot carefully and leave room for cropping. A 5"x7" enlargement uses almost all of the negative.

When making a rectangular print from a square negative, cropping will occur. An 8"x10" enlargement preserves more of the frame. The square negative also allows you to print verticals, horizontals and squares from the same negative.

■ Other Essentials

Light Meter. A great light meter and a Polaroid back are essential pieces of equipment for any professional. The light meter measures the light output from the strobes or from the available light. It is important to buy not just an available light meter (the kind that is in most 35mm cameras) but one that will also work as a flash meter. It is essential to good exposure to know what your light output is. Each light is metered separately and then together. The lights are adjusted to output what f-stop you want to work at. The power is adjusted up and down accordingly.

Polaroid Back. A Polaroid back is a foolproof way of eliminating mistakes. After your lights are set (but before photographing the client), take a test shot. If you like, the first portrait of the child can be the test shot—but I hate to leave a child hanging around waiting once he is on the set. Instead, we use a giant teddy bear to simulate the client when we run test shots. Polaroid 689 film is the richest and most accurate of all I have seen. It also takes the longest to develop fully—ninety seconds. The Polaroid will let you know immediately if one of the lights is not firing or if the background light is too hot. It will reveal any glaring lighting errors, saving you endless hours and money spent retouching or custom printing.

◼ Lighting

Once your choice of camera is made, the next decision is lighting. Many beautiful portraits can be done in the studio using only two lights and one or two reflectors. The more lights you add, the more depth and highlights you can create in the portrait. Beautiful, soft and sensitive close-ups can be achieved with two lights and two reflectors: a mainlight, background light, a reflector under the face and a reflector on the opposite side of the subject from the mainlight. This creates a "tent" effect, eliminating all shadows. This type of lighting is pleasing to the majority of mothers, since it's what they are accustomed to seeing in magazines and on television.

Studio lights that are self-contained and not on the camera are called strobe units. My choice for strobes is Photogenic Power Lights, but there are many brands of this type of lighting. Professionals rely on strobes for many reasons. One reason is their consistency with exposure over and over again. Another is the ability to "see the light" through the use of modeling lights that are built into the unit.

ONCE YOUR CHOICE OF CAMERA IS MADE, THE NEXT DECISION IS LIGHTING.

Light Modifiers. Strobes need to be fitted with light modifiers to be truly effective. Light modifiers include soft-boxes, umbrellas, grids, snoots, barndoors, diffusers and other assorted items used to direct the light in specific ways. The two most essential light modifiers are umbrellas and softboxes.

Umbrellas come in a variety of fabrics each with a specific purpose. An umbrella, for example, is designed to allow the strobe light to hit the inside of the umbrella and bounce back onto the subject. The inside of an umbrella can be white (softest effect), silver (hard bounce with bright reflections) or a mix of the two often called a Zebra (soft light with a good highlight). The larger the umbrella, the softer and larger the return of light. No matter what the interior color of the umbrella, it is best to use one that has a black cover on the outside so your light is all directed back at the subject instead of getting lost through the fabric.

Light Quality

Whether light is harsh (creating rapid transitions between shadow and highlight) or soft (creating gradual transitions between shadow and highlight) is directly related to the size of the light source relative to the subject.

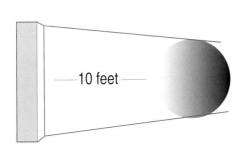

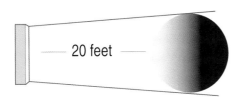

At the identical setting, a light source placed ten feet from a portrait subject creates softer shadows than the same light placed twenty feet away. This is because, by moving the light farther from the subject, the relative size of the light source is decreased (making the transition between highlight and shadow areas take place over a smaller area). For example, the sun is a huge light source, but because it is so far away, it creates extremely harsh shadows on a clear day. Conversely, on a cloudy day, the entire sky acts as the light source. Although the sky is much smaller than the sun, its relative size to us is much larger, because it is also much closer than the sun. Consequently, the clouded sky creates much softer shadows. The same situation occurs when using a light modifier, such as a softbox. While the strobe bulb is quite small, the modifier increases the size of the light relative to the subject and yields softer shadows.

Softboxes can be used alone or mixed with umbrellas and reflectors. A softbox contains and directs the light, giving more control over where it falls. Light from a softbox also falls off faster than light from an umbrella. The larger the softbox, the softer the light. Also, the closer your light is to the subject the softer the light.

How do you decide when to use a softbox or umbrella as your main source of lighting? An easy rule is to look at your background. An umbrella creates "spill" light, meaning the light does not fall *just* where it is pointed. If your background is light, it usually doesn't matter if it gets some spill light. A dark or textured background, however, could become totally washed out and disappear with too much light hitting it. So, when the background needs more controlled lighting, a softbox is essential.

HOW DO YOU DECIDE WHEN TO USE A SOFTBOX OR UMBRELLA AS YOUR MAINLIGHT?

Light Ratio

The difference between the light side of a subject and the dark side can be expressed as a ratio. The higher the ratio is, the greater the contrast between the two sides.

For instance, a 1:1 ratio would indicate that there is no difference between the light side and the shadow side. At a 2:1 ratio, the light side is twice a bright as the shadow side (which is to say, there is a one-stop difference between the meter readings for each side). This lighting ratio will display soft but visible shadows. In a 4:1 ratio (light side two stops lighter than dark side), the shadows will be much darker, but with some detail. At an 8:1 ratio (light side three stops lighter than dark side), significant loss of detail will occur in the shadows.

The normal range for portrait photography is between 1:1 and 4:1, but children's portraits tend to be shot at 1:1 or 2:1.

To measure the light ratio, meter the light side of the subject, then the dark side. Then count the number of stops difference between the two. If the ratio is too high, add more fill light (if using a strobe, adjust the setting lower; if using a reflector, move it closer to the subject), or reduce the setting on the mainlight (or move it father away).

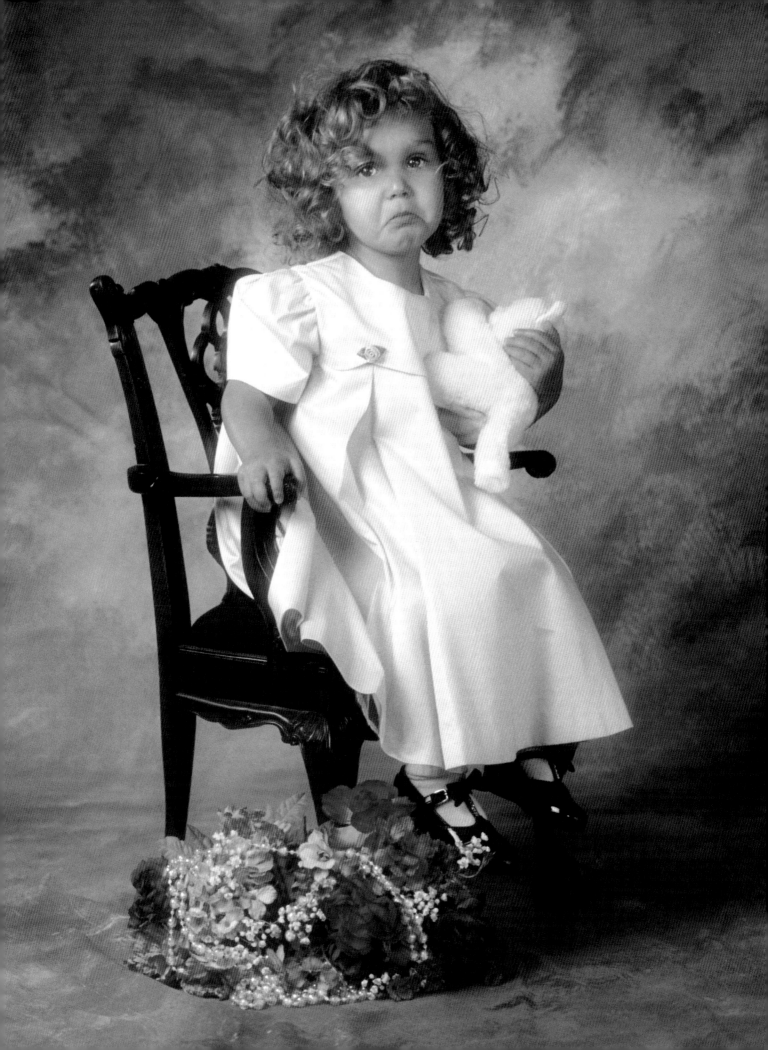

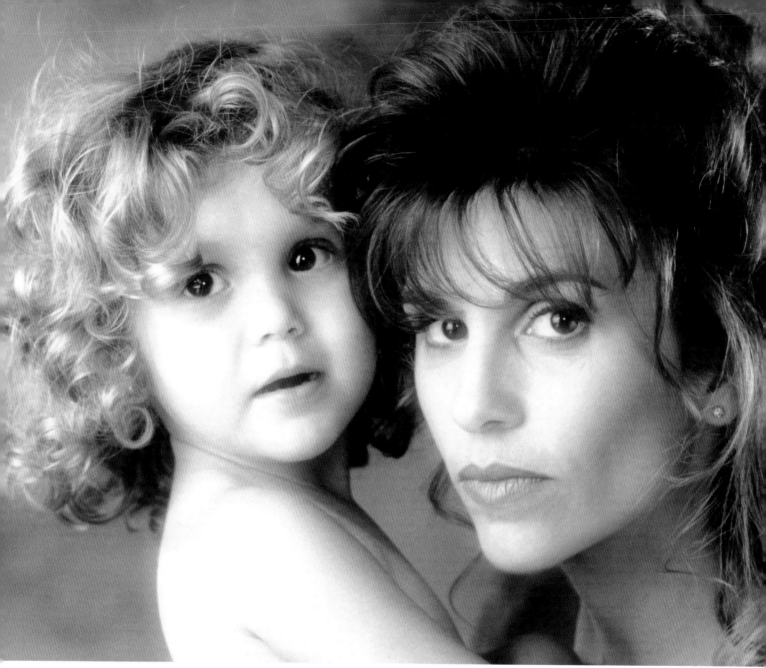

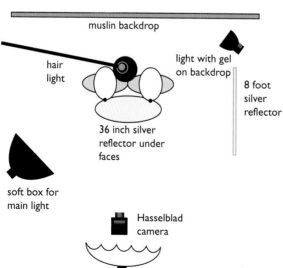

muslin backdrop

hair
light

light with gel
on backdrop

8 foot
silver
reflector

36 inch silver
reflector under
faces

soft box for
main light

Hasselblad
camera

umbrella for
fill light

ABOVE: A hairlight was used to accentuate the tendrils of hair. The nude look keeps the viewer's eye focused on the subjects. The lighting diagram shows the setup for this portrait.

OPPOSITE: This is another example of simple lighting. A softbox was used as the mainlight, and an umbrella was used for fill light. A reflector placed to the boy's right helped bounce light into his hair. A spotlight was added on the backdrop to help bring out the second boat in the image.

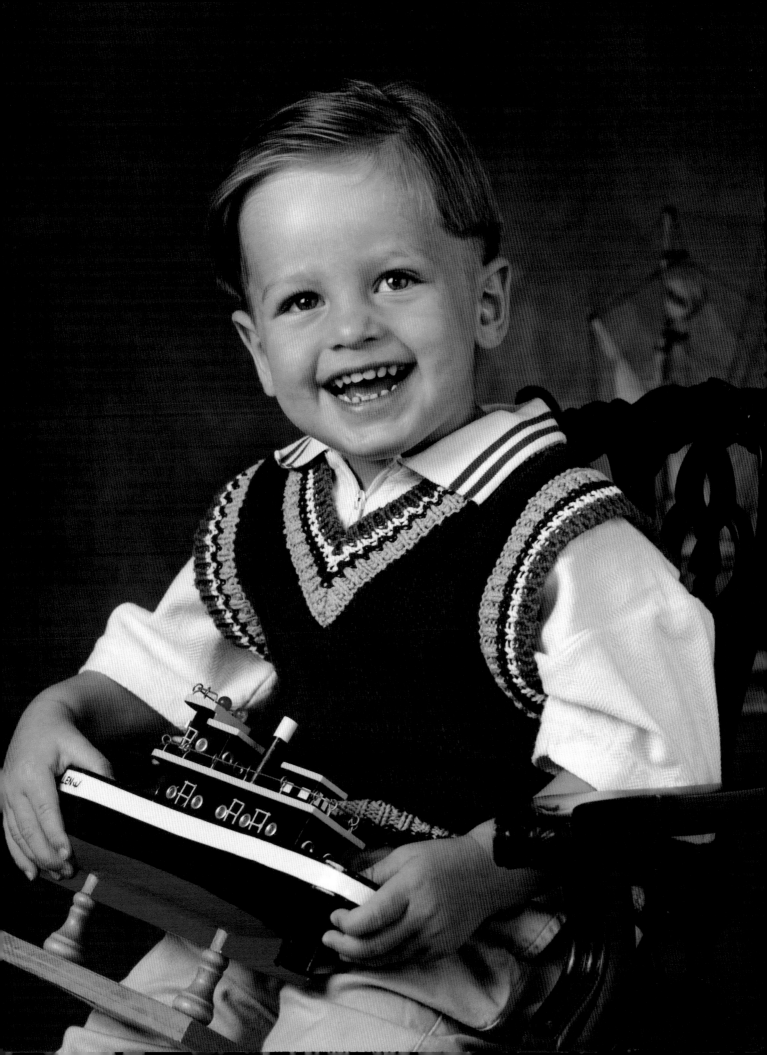

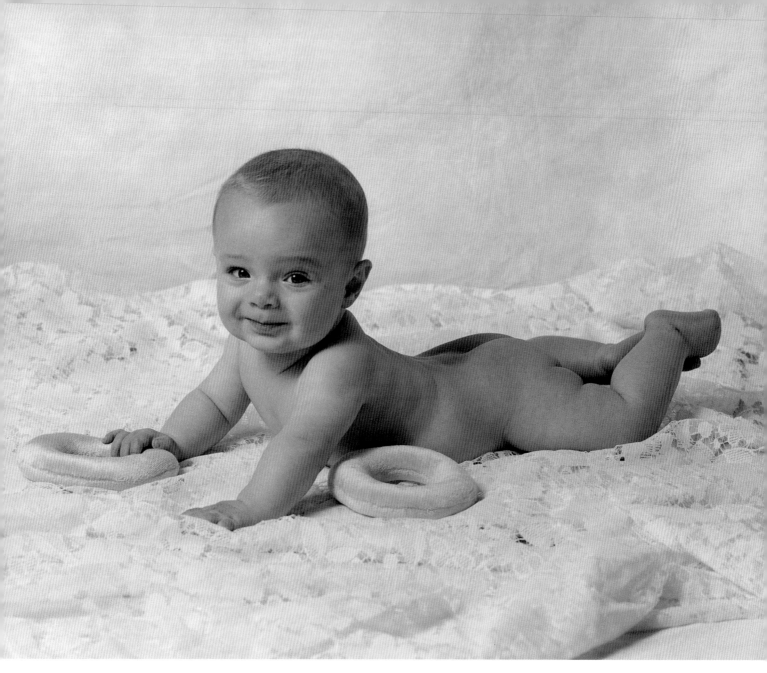

The umbrella and the softbox are used as your "main" and "fill" lights. The mainlight is the primary light source for your subject. The fill light does just what the name implies: fills in the shadows. How much it fills in the shadows determines the lighting ratio. This ratio is the difference in f-stops between the light on the highlight side of the face and the shadow side of the face. It is usually expressed as a proportion, like 3:1. A portrait with a 3:1 ratio has deeper shadows than a 1:1 ratio. Most children's photography is done with a 1:1 or 2:1 ratio unless a special effect is being created. This

A baby doesn't have to have a huge smile to show he's happy. This little guy is obviously comfortable and his expression shows it.

The classic look of this formal portrait will never go out of style. The background is intentionally kept dark to match the subject's clothing and allow their skin tones to stand out. A softbox was used as the mainlight, an umbrella was used for fill. Large reflectors were placed both on the right and under their faces to complete the setup. The light bouncing off the large reflector to the right also serves to illuminate the subjects' hair.

means that the only shadows on the face are extremely light and open.

Reflectors. Reflectors are considered a necessary part of lighting equipment. The reflectors used the most are round 36" or 48" white or silver ones, and the 4'x8' standing silver reflector that can be converted to white, silver or black with elastic fabrics that go over the frame. The round reflectors are used either under the face or to the fill side of the face. This is where the modeling lights on the strobes make lighting easier. When placing the reflector it is important to know if it is actually reflecting the light. Has it "caught" the light and is it bouncing it back into the subject? The easiest way

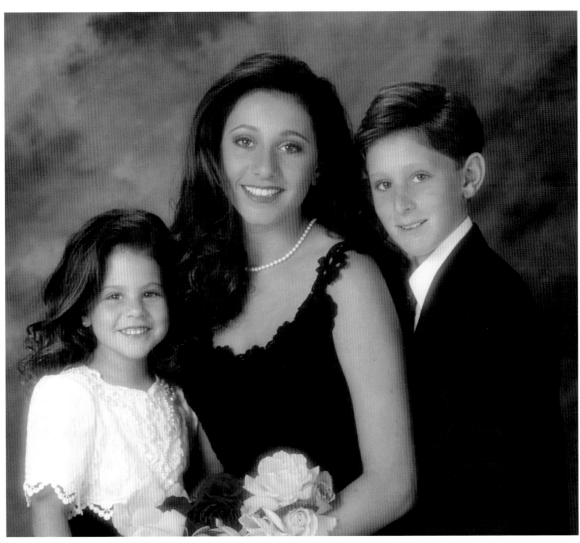

to know is to look at your subject's eyes. Play with the reflector until you see highlights appear in the eyes. A reflector under the chin just out of camera view will create a second highlight in the eye on the bottom of the iris. This means that two highlights will appear in the eye. This lights up the eyes and makes them look even more sparkly and lively.

Raising your camera to shoot at the baby on his back gives a different angle on the baby and usually will wake the baby up for some new expressions. Be careful that private parts are covered up when you photograph.

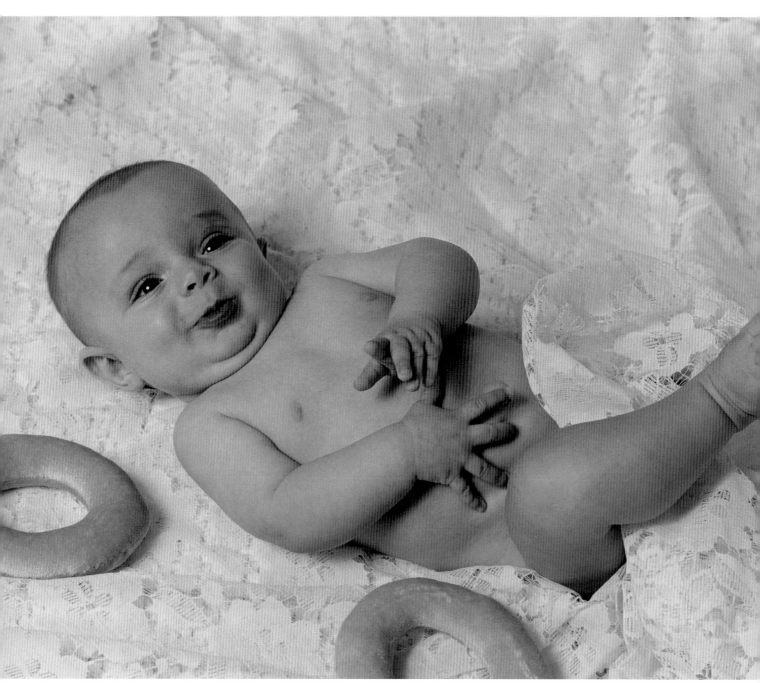

Little boys are not always dressed the neatest, but the expression is what counts and this one is angelic. Be ready to capture such moments in a flash.

Portable strobes are those that may be used on- or off-camera. They do not have modeling lights, so you can't see the effect of the light before photographing. The only way to see what the portable light is doing is to take a Polaroid test exposure.

There are many, many portable strobes. The important features are power and flexibility. My preference is the Vivitar 285. The 285 has a head that not only gives telephoto or wide-angle coverage, but also can be moved up to bounce the flash from the ceiling. My favorite feature of this flash is the ability to reduce its power output (or manual down) to $^1/_{16}$ second. Built into this flash is a guide that helps you set it correctly for the film speed and the distance from the subject. It can also function as a great little "kicker" light in the studio, when used with a slave that sets it off at the same time as the mainlight.

You can use multiple flash setups with these units and/or mount them in umbrellas to simulate studio strobes. They can even be a decent backup lighting system in your studio when there aren't enough funds to purchase extra studio strobes.

■ *Accessories*

It is clear that the right studio equipment is necessary to create true, studio-quality lighting. There are also a number of accessories that will enhance those portraits.

Diffusion Filters. Diffusion filters come in every shape and type. There are behind-the-lens filters, in-front-of-the-lens filters and even in some cases, actually in-the-lens filters. The amount of diffusion that should be used must be determined by personal taste. Some types of diffusion can create mood and do more than just soften the image. They can produce dreamy, almost surreal effects. Sometimes, these effects happen when we don't want them to happen,

This is a classic little boy portrait—small, simple "boy" props and solid colored clothing on a textured muslin backdrop. With this type of background, it's important to balance the background lights so they don't overexpose the background and eliminate texture.

though, so it's best to test and know your diffusion. One of the effects most people *don't* like is when the whites in an image are flared into the skin and background creating a "halo" effect around the subject. The studio situation where this can be a real problem is when photographing a person on a white background and using diffusion. When photographing on a white seamless background, it is best to not use any diffusion. It is safer, and the lack of softness gives the portrait a high-tech, snappy, magazine quality. This is one of the most popular backgrounds with babies and children.

Diffusion Alternatives. For dreamy effects on a painted background or muslin, try the old diffusion standbys—which only cost pennies. One is a nylon stocking pulled tightly over the lens. Another is black, tightly woven tulle over the lens. Both require the lens be opened up one stop, as these materials will block the light to the lens by approximately one stop.

Minimum Needs

Below is a list of the absolute minimum of equipment needed to create professional studio portraits of children. Of course, you may choose a 35mm outfit instead of a square medium format one. It is also worth mentioning here that most of this equipment can be bought used through various photo dealers and at photo flea markets. If buying used equipment, be sure to pay immediately to have it overhauled and checked out by a professional service center. The cost of used equipment plus the overhaul will still offer huge savings over buying the equipment new.

- ❏ Hasselblad or other square format body
- ❏ 220 back (24 exposures)
- ❏ 150mm or 180mm lens
- ❏ Lens shade to prevent light hitting from lens and to hold filters

- ❏ Solid tripod or camera stand
- ❏ Three strobe lights
- ❏ Two umbrellas (one white, one Zebra, both 45")
- ❏ One softbox
- ❏ 36" silver reflector
- ❏ 4'x8' reflector

CHAPTER 5
CHOOSING THE RIGHT FILM

For studio portraits, I always rely on tried-and-true films that produce consistent results with no surprises. That way I can concentrate on posing, expression and lighting. The new Kodak films have proven to meet the demands in a busy studio.

◼ *Color Films*

Kodak Portra 160 NC (natural color) gives subtle color and natural flesh tones in controlled lighting situations. The true 160 film also has exposure latitude that covers you when the studio flashes don't recycle to full power as quickly as your trigger finger is shooting.

Kodak Portra 160 VC (Vivid Color) captures enhanced color in scenes with one predominant color or flatly lit situations. Anytime you are looking for more punch in a monochromatic scene or in high key portraits, this is the film to use.

These same films also come in 400 speed. Use 400NC or 400VC when you have a low light situation. Another reason to use this speed film is that your studio strobes can be set at a lower intensity, thereby getting you a faster recycle time. In the studio, it would be difficult to tell if a finished portrait was photographed on 160 or 400 film.

The best images are made or lost in a split second—so be ready for the unexpected! For black & white portraits, a good film choice is Kodak TMAX.

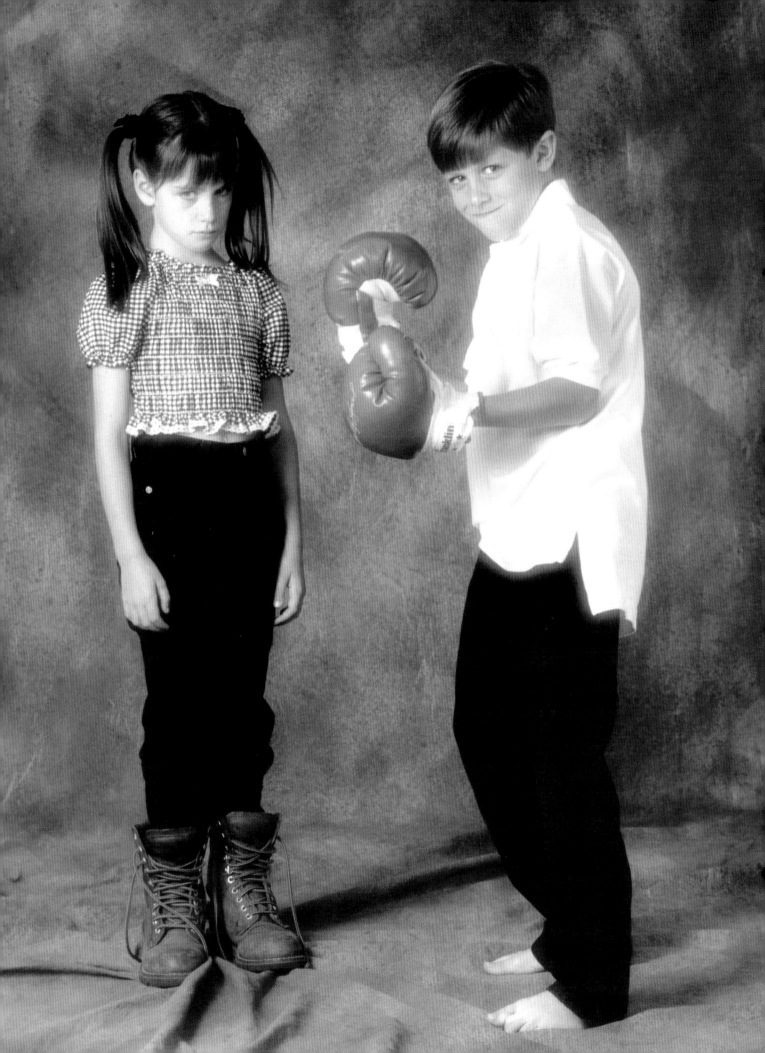

Black & White Films

Kodak has also come out with amazing new technology for a new Professional Portra black & white film. This film is processed in the color chemistry and printed on color paper. This is a great convenience to studios because it means that all the film, both black & white and color, can be sent to one lab for processing.

For more traditional black & white studio portraits, Kodak TMAX 100 is the film of choice. It is very important to remember that good black & white portraiture is a marriage between photographer and lab. Black & white film needs to be processed precisely by a custom lab, and your prints need to be printed in the freshest chemicals by a professional. A great black &

GOOD BLACK & WHITE PORTRAITURE IS A MARRIAGE BETWEEN PHOTOGRAPHER AND LAB.

white negative could end up being printed flat and gray by a mass-marketing lab that doesn't specialize in black & white film. There is a good black & white lab in every city, check your local phone book and don't leave it to chance.

Polaroid Films

The Polaroid film in your film back is just as important as the film in your camera. If the film chosen doesn't realistically show the lighting, then it's useless to shoot Polaroids. The vivid and bright Polaroid 679 film with a speed of 100 gives an accurate preview of what you see you will get on film. The film is so rich and bright, we often give our clients the Polaroid to take home to enhance their excitement about the portrait session.

This is the group of films that will cover all your camera room needs for photographing babies and children. Almost anything can be done with them to create images that sparkle and glow with rich colors and subtle, realistic skin tones.

There are other specialty films that are fun to experiment with, but the results are not as reliable as the aforementioned films. Some films that are worth experimenting with are:

Kodak T-MAX 3200 High Speed Black & White Film (TMZ). This is a multispeed panchromatic negative film that combines very high to ultrahigh film speeds with finer grain than that of other fast black & white films. This film allows you to photograph in extremely low light situations. The film speed is variable with push processing. It can be rated from 800 to 25,000 depending on your needs.

Kodak High Speed Infrared Film (HIE/HSI). Another fun film to experiment with is infrared film. Infrared films are specially sensitized to record the near-infrared range of the electromagnetic spectrum, as well as visible light. Working with this film will require some experimentation. Have some fun with it and try it out in the camera room. Characteristically, black & white infrared photographs are mysterious and ethereal in appearance. Prints look grainy with a glow occurring quite often around lightly colored or white objects. Used properly, this film can give very creamy and almost white skin tones that are especially nice for handcoloring.

BLACK & WHITE INFRARED PHOTOGRAPHS ARE MYSTERIOUS AND ETHEREAL IN APPEARANCE.

EASY AND EFFECTIVE LIGHTING

The simplest typical studio lighting setup involves only three lights. A mainlight, fill light and a background light. The mainlight might be set at f/8.0. The background (if it is a dark background) could be a full stop more than the mainlight, making it f/11.0.

The fill light would be either f/4.0 or f/5.6, depending on how much fill you desire for your portrait. The camera is set at f/8.0. Because the studio strobes will effectively control all your lighting, the shutter speed only needs to be fast enough to shut out any extraneous light. If you are photographing a room with a great deal of available light and it is important that none of that light be in the portrait, then shutter speeds of $^1/_{125}$ second (or less) are necessary. I generally prefer to photograph at $^1/_{125}$ second in the studio. This ensures that none of the fluorescent or other lights are damaging what I expect my final lighting to be.

In this setup, the mainlight would be placed to the left of the subject with a reflector on the opposite side. The fill light would be positioned next to the camera (on the same side as the mainlight). The background light would then be placed behind the subject and pointed at the background. If

OPPOSITE: Beautiful eyes are emphasized in this portrait. Having her look at the mainlight instead of the camera puts the focus on her eyes and eye color. Eye color is enhanced by a bright modeling light that forces the pupil of the eye to shut down and show more of the iris.

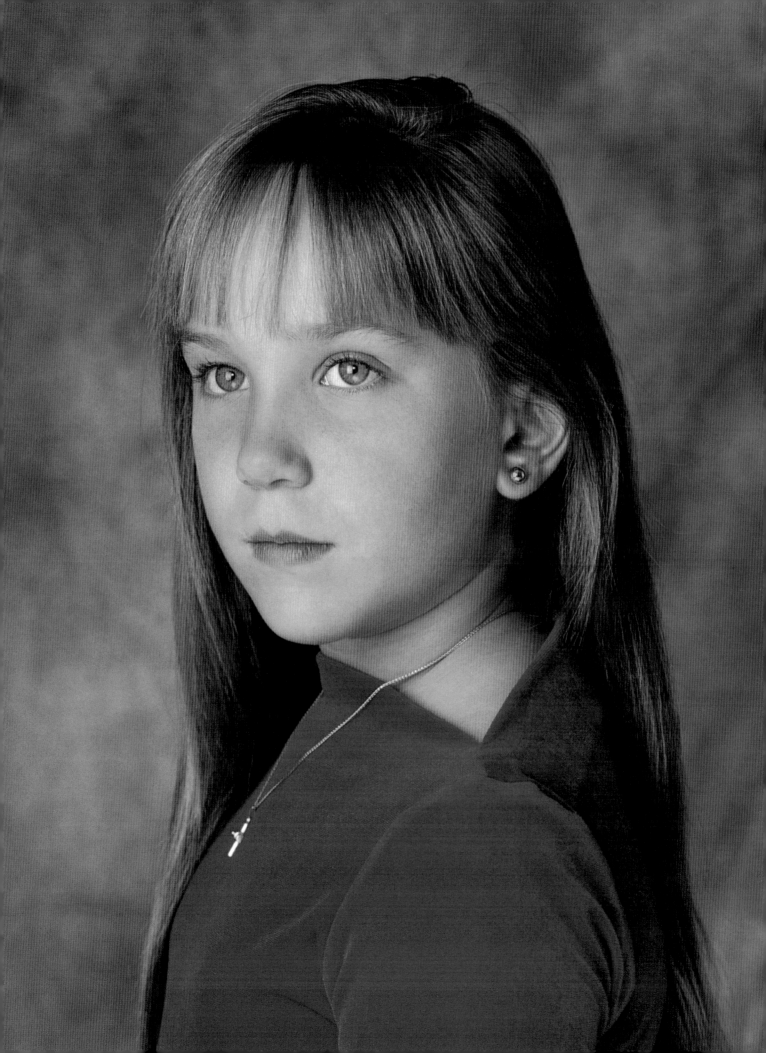

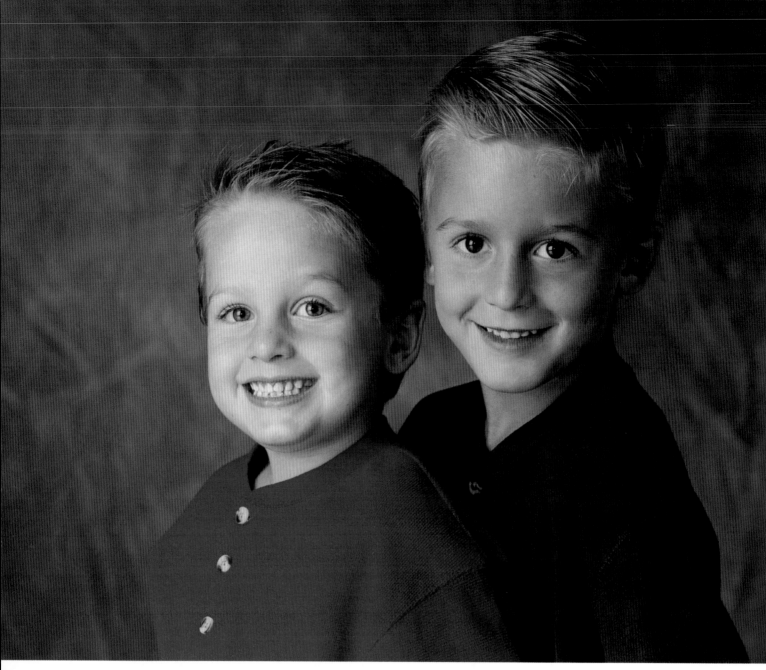

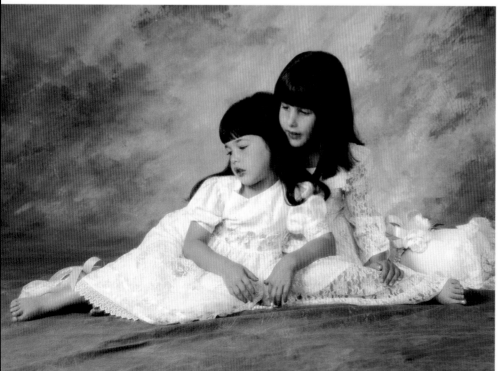

ABOVE: Can't you just guess which one of these boys is the mischievous one? This brown background perfectly blends with their shirt colors and lets their faces glow.

LEFT: These sisters will probably never be closer than at this moment. Tell them what to look at so they have a focus point. Be sure the hands are showing and laying gently on the fabric.

the portrait is full-length, the background light can be off to the side of the background, pointed at the background and fitted with a grid to direct the light.

▣ Two Light Setup

It is also possible to light a portrait with only two lights. The trick is to use reflectors effectively. The first light placed is the mainlight, usually on the left of the camera. The second light can function either as a background light or as a hairlight. The reflector is then used in one of three places. First, it could be placed on the right side of the subject to bounce the mainlight back into the face. Alternately, it could be placed underneath the subject's face so that it catches the light from the mainlight and floods the face with

Sometimes you just have to be fast to catch the portrait before the baby runs off the backdrop! Placing the baby far away from the background allows for the softness in the image. The background is not sharp but, instead, falls just out of focus.

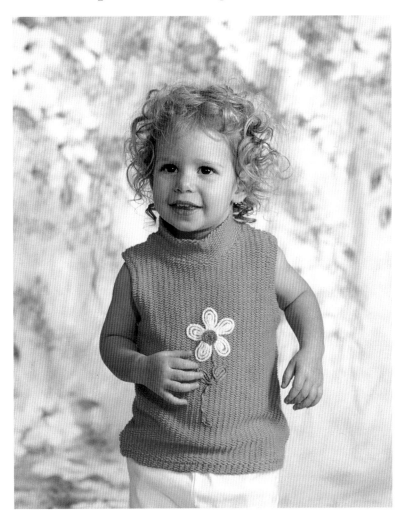

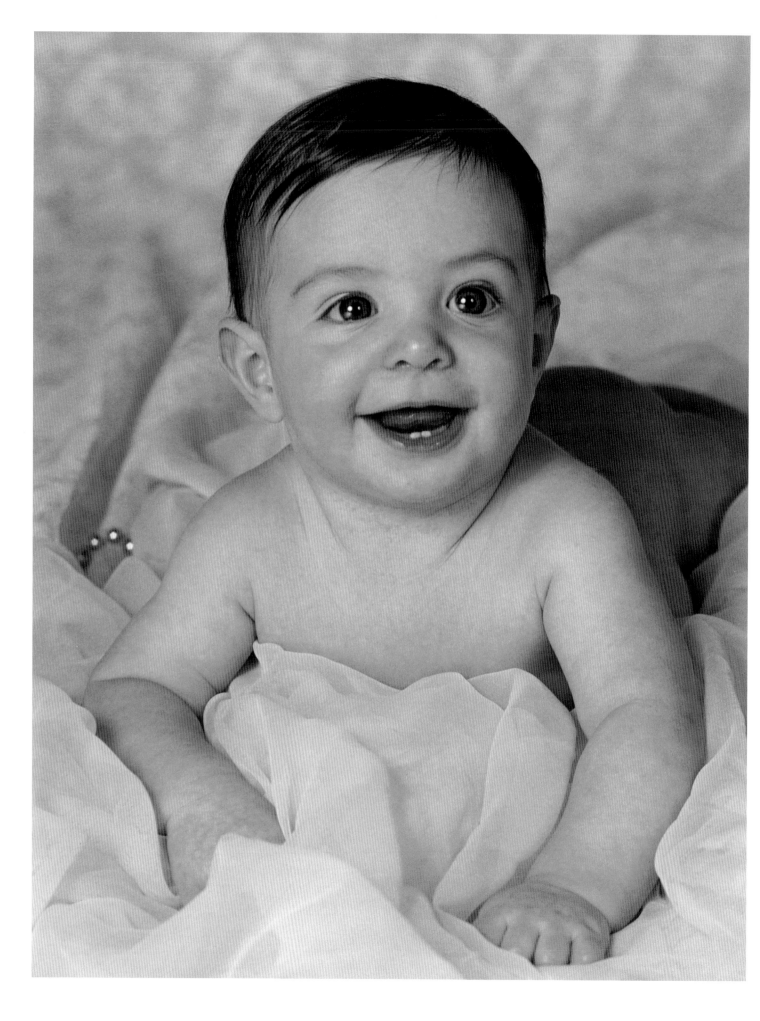

OPPOSITE: You can clearly see in the baby's eyes that two lights and a reflector were used to photograph her. A slightly higher camera angle helps to stretch her neck and captures the shape of her face beautifully.

BELOW: When lighting props such as these, the lighting must be even so as not to overexpose the props. Also, be sure to light up the background behind the props so it won't go dark.

a glow, adding bottom highlights to the eyes. Finally, the reflector may be placed over the subject's head to catch the mainlight and create a spill of hairlight.

As you can see, there are many ways to light one subject. They are all correct and the choice as to which to use is up to you, the artist. Your selection will be determined by what you are trying to convey in the portrait. Other lights can also be added to either of these basic lighting setups. You may, for example, want to add "accent" lights or spotlights. These can emphasize faces, fabrics or just the shoulder of the subject. Extra lights add more dimension to your portraits and give a more rounded feeling to the subjects.

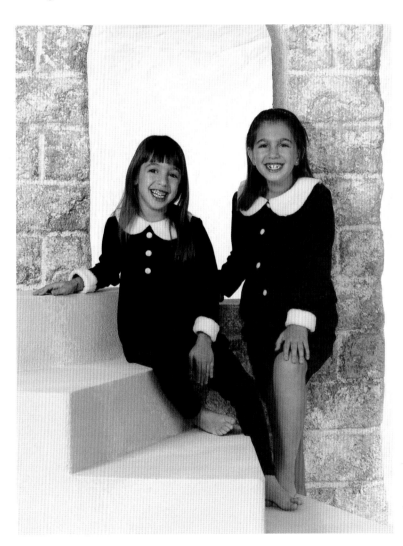

Effective Background Lighting

Controlling how the background is lit can change the entire mood of your portraits. The light on the background can create total separation between the subject and background or illuminate the background evenly. It can also create a vignette effect, or illuminate the background so that it becomes an important part of the portrait. Sometimes it is interesting to highlight props in the background and not to flood the background with more light.

In middle key (clothing and background that is neither very dark or very light) or high key portraits (light

background and light clothes), it is important that the background doesn't distract from the subjects. The best choice is usually to light the background evenly, without any bright spots to pull the eye away from the subject. Sometimes, it is lit at exactly the same ratio as the mainlight.

A dark background combined with dark clothing is called a low key portrait. Low key portraits allow the face to stand out as the first place the eye goes to in the portrait. Many times low key portraits incorporate Rembrandt lighting. This lighting pattern is very specific and brings out the highlights of the face and enhances detail in the clothing.

A DARK BACKGROUND COMBINED WITH DARK CLOTHING IS CALLED A LOW KEY PORTRAIT.

Dark clothing on a light background is very contemporary and striking. Bright clothing in primary colors on white is crisp and sharp. Those portraits have a magazine quality about them. Those backgrounds must be lit to be lighter than the subjects' faces.

Lighting Patterns

Lighting patterns refer to specific, standardized positioning of the main and fill lights to create a desired pattern of shadow on the subject's face. Some common lighting patterns are listed below.

• Rembrandt Lighting

The subject's face is lit from 45 degrees to one side, creating strong shadows. The shadow from the nose falls on the subject's cheek and merges with the shadows on the unlit side of his or her face. This pattern divides the face into two sides and gives shape and depth to the model's features.

• Butterfly Lighting

The mainlight is placed close to the camera position, creating a shadow directly under the subject's nose. The face will be evenly lit.

• Loop Lighting

Popular for portraiture, the mainlight is placed 20 to 25 degrees to one side of the subject, and slightly higher than the subject's head.

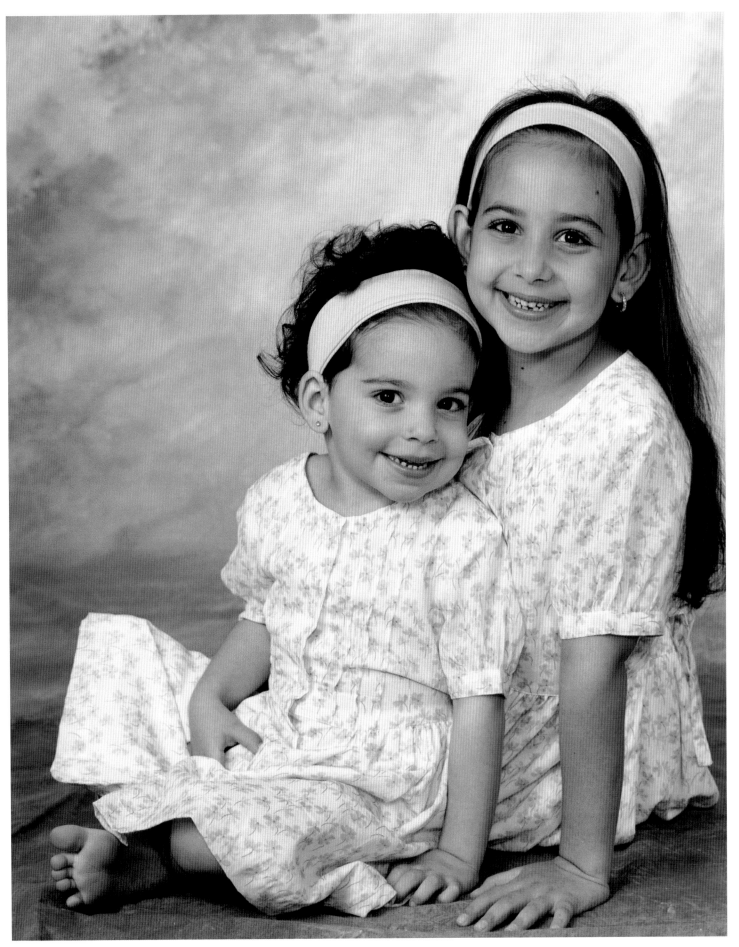

Brown-toned (or sepia) black & white prints are always in style. The background is overexposed here by two stops to create the light area behind their dark hair.

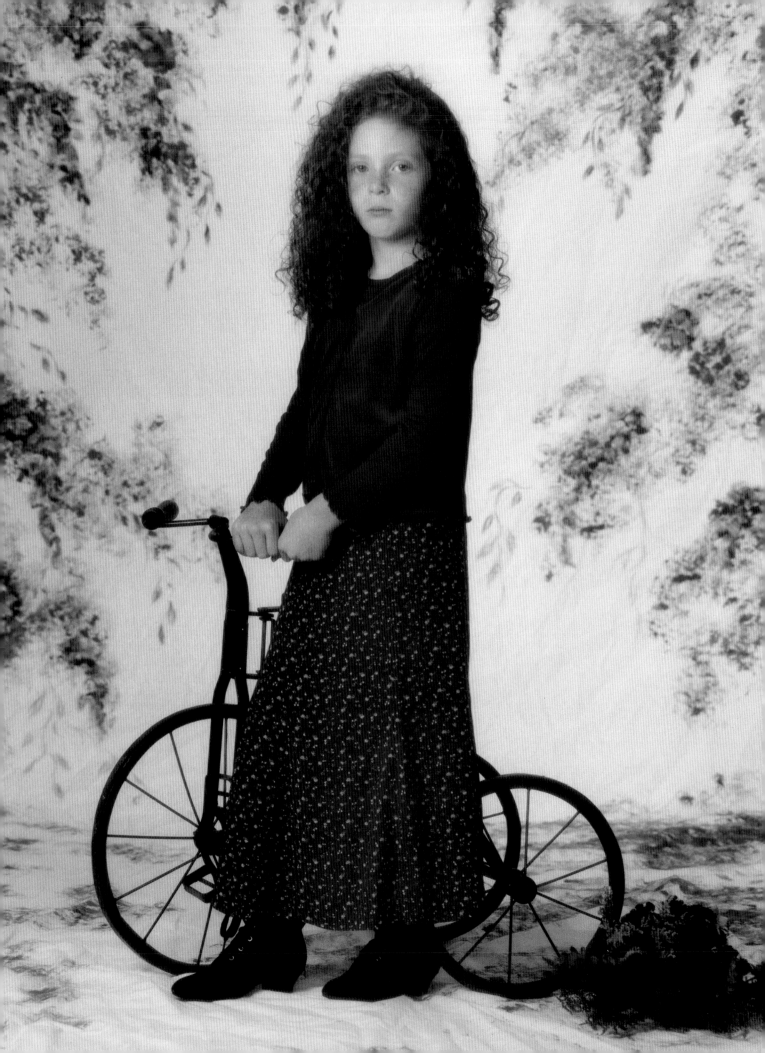

OPPOSITE: This little girl had an old-fashioned look about her, so we teamed her up with a floral background and an old-fashioned tricycle to emphasize it. When using a printed background, be careful not to overexpose it with the background lights. Use your flash meter to be sure the entire background is evenly lit.

RIGHT: Close-ups are wonderful. This baby's beautiful smile is enhanced because there is nothing around it to distract us. The lighting remains simple, consisting of a mainlight with an umbrella, a fill light with an umbrella and one background light.

◻ *Conclusion*

Lighting is a highly personal decision. While there are rules of lighting and techniques that work best, it is ultimately up to you to decide what mood you are creating and then convey it with your choice of lighting. Because children and babies have short attention spans and are very active, it is usually best to use simple lighting setups so the concentration is on posing and expression.

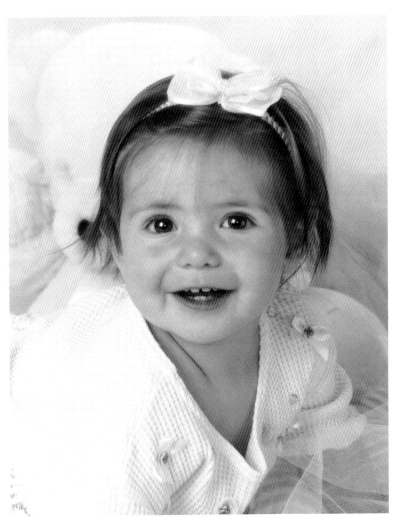

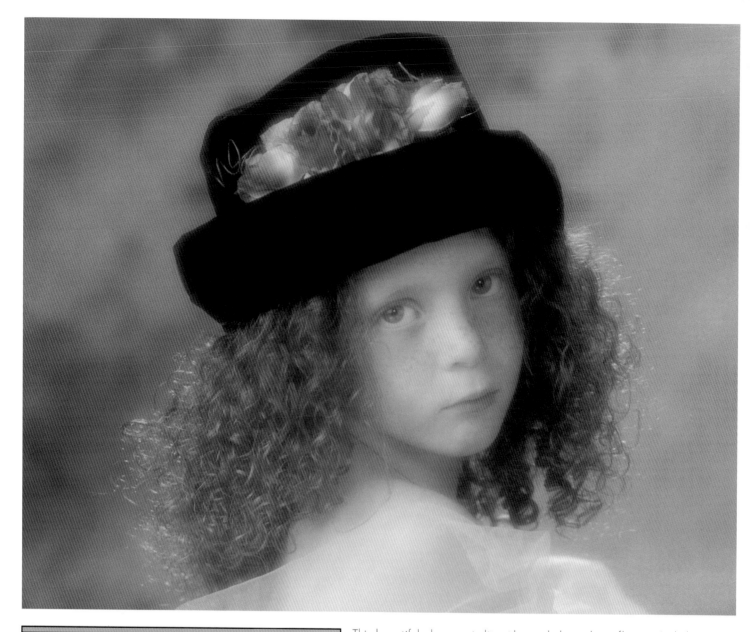

hairlight from behind

light with gel on backdrop

muslin backdrop

36 inch reflector

soft box for main light

Hasselblad camera

This beautiful close-up is lit with one light and a reflector. A light was placed behind the subject to light her hair and bring out the curls. A pink gel was used on the background light to get more color saturation in the pinks. No fill light was used. The black hat helps keep your eye on the little girl's face.

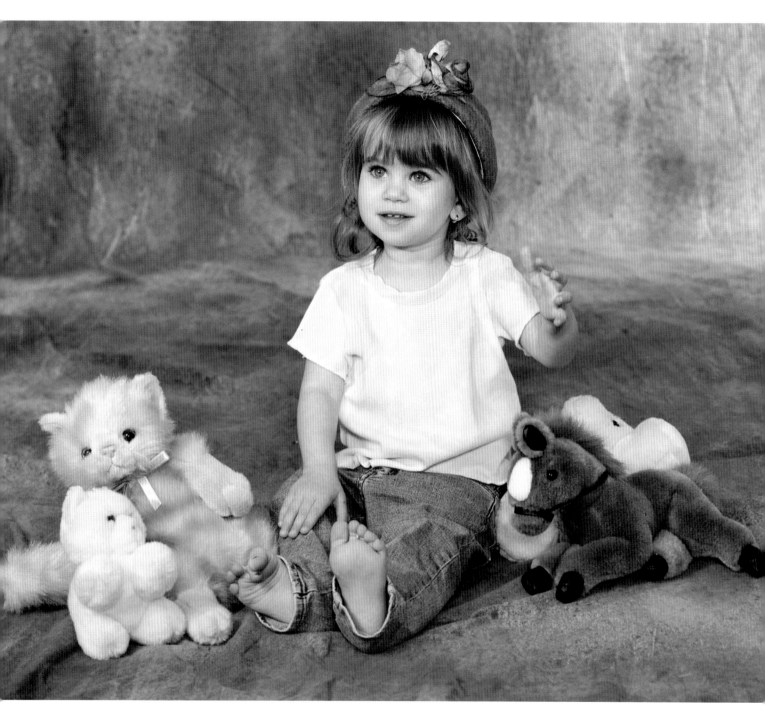

Handcoloring parts of a black & white portrait adds a second dimension to the image. Be sure not to overdo the coloring and only do small parts of the image.

CHAPTER 7
ARE YOU A PHOTOGRAPHER OR AN ARTIST?

Style is what separates artists from "shooters." An artist visualizes the final product and creates a portrait of a child. A photographer takes some photos of children hoping to get "something." An artist encourages expressions and knows how to make them happen. A photographer waits and waits until an expression emerges.

■ *Game Plan for Style*

Even if the planning involves all of ten minutes after meeting the client, there is always a game plan for the portraits with an end result in mind. This is what artistic photographers do. They plan and visualize and eventually direct the portrait into a finished product.

One of the "trademarks" of my own photography is expressions that evoke emotion and are natural. The moments I capture are fleeting and few—and ones that parents recognize as depicting their children in their most happy, unguarded or emotional of moments. When I started out in portraiture, I knew I had to create a type of portrait that was not available from other photographers in the area. No one at that time was photographing children "high key"

(on a white background) in my area. I learned how to do that and, combined with my timing for expression, I quickly created a style for myself that to this day, people still associate with my studio—even though the percentage of high key portraits we do now is less than 50 percent of the total.

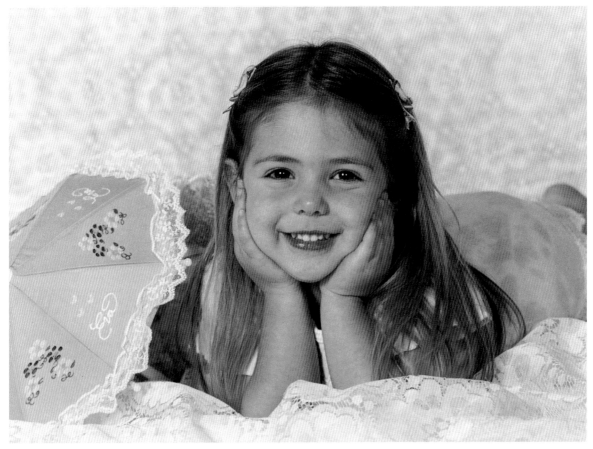

ABOVE: Use your client's own props and let little girls do some "posing" of their own. This beauty couldn't wait to show me her idea for a portrait.

NEAR RIGHT: Serious expressions can be wonderful—especially with the eyes turned to the camera.

FAR RIGHT: Eyes directed away from the camera and into the mainlight create an intimate feeling—like there was no camera!

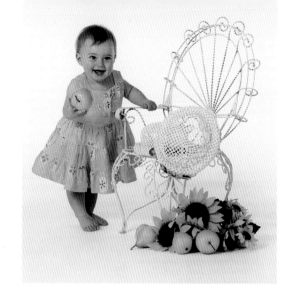

RIGHT: The flowers in this high key portrait match the baby's dress and tie the whole portrait together.

BELOW: This China-doll face was made even more special by adding softness all around the base of the chair. This brings your eyes to her eyes. The small chair is great for babies who are not quite sitting on their own and is a great prop to have on hand.

OPPOSITE: Here's a good example of the visual effectiveness of matching the props to the clothing.

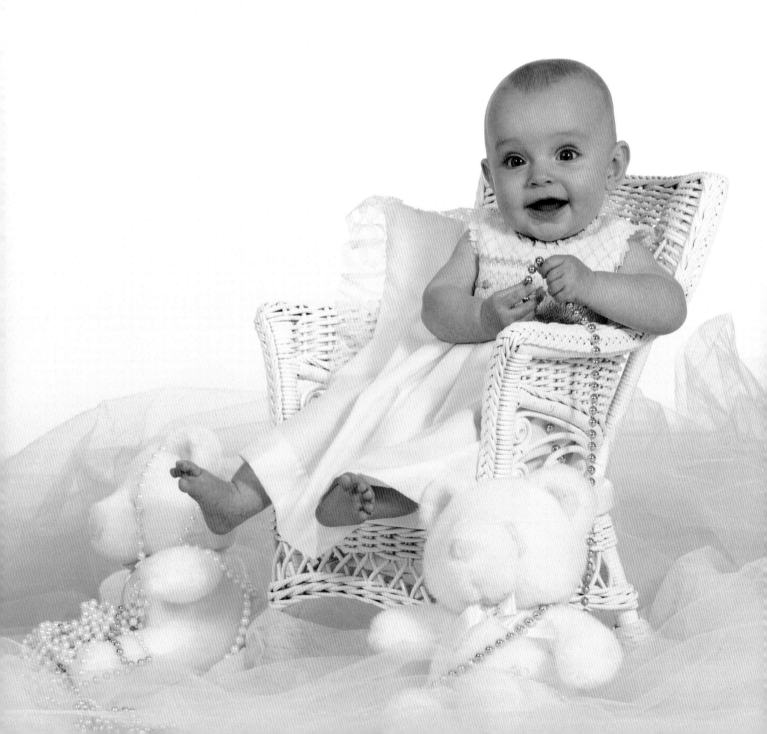

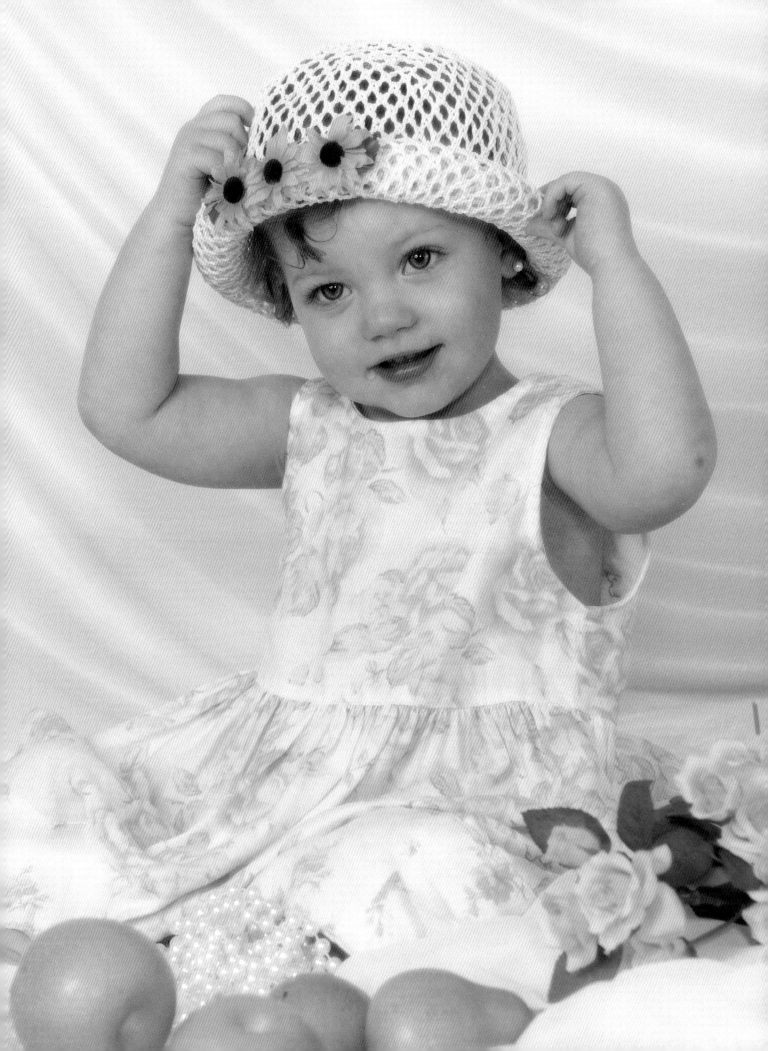

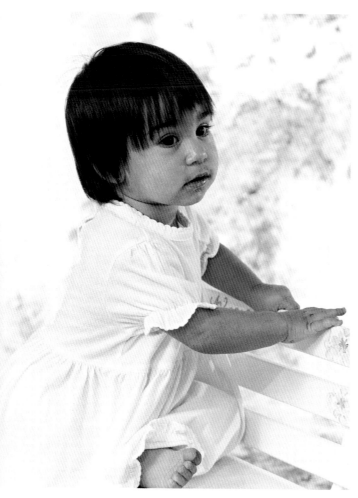

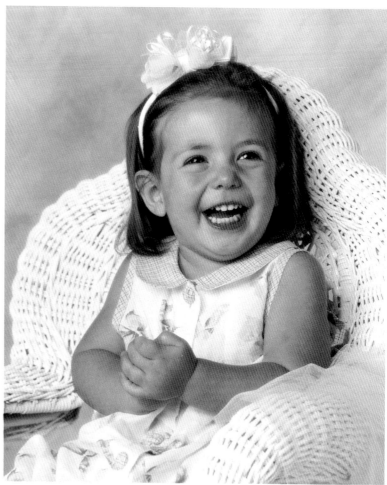

ABOVE, LEFT: Capturing a baby's mood when they think you are not photographing them can yield a most rewarding portrait. This background is two stops overexposed to create the pastel look that matches the baby's chair.

ABOVE, RIGHT: Notice the tulle placed on the arm of the chair. Seems like a small detail, but it softens the image and adds dimension.

RIGHT: Directing the child as to what to do with the props is important. All children know how to give hugs.

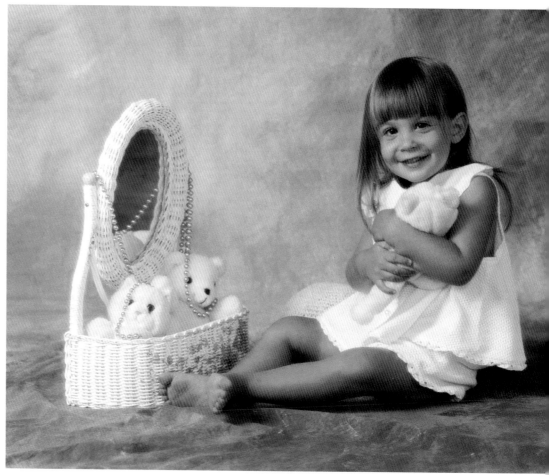

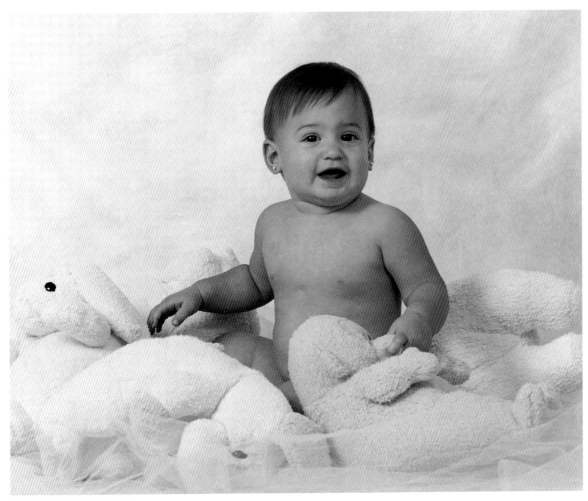

LEFT: This nude baby is surrounded by similar toys that all have an interesting texture to them contrast with the baby's smooth skin. The background was evenly one stop overexposed to give it a matching pastel color.

BELOW: It's not always important to show the face to have an unforgettable portrait. The little boy was just not ready to have his portrait taken. Notice how the boxes on which the toy planes are set up were all covered with soft fabric to give the floor of the portrait a very soft look. The little girl was directed to look at her shoe, and her body language is just plain beautiful.

Pose them, then make them laugh—what could be more perfect? The diagram to the right shows the lighting setup used to capture this portrait.

white seamless paper

light on backdrop

light on backdrop

umbrella for main light

Hasselblad camera

umbrella for fill light

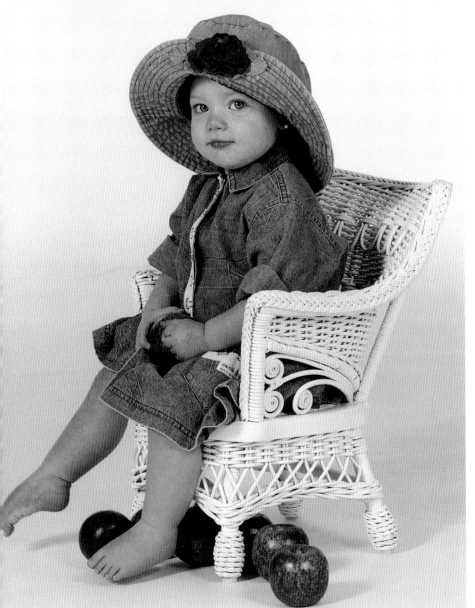

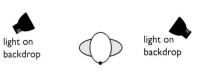

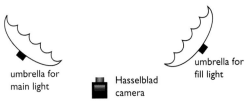

light on
backdrop

light on
backdrop

umbrella for
main light

Hasselblad
camera

umbrella for
fill light

TOP, LEFT: Always be ready for that moment when a perfect expression matches the perfect body movement. The diagram above shows the lighting setup.

BOTTOM, LEFT: We gently tossed the baby into the stuffed animals and encouraged him to crawl back to us for more. This game works over and over again. The diagram below shows the lighting setup.

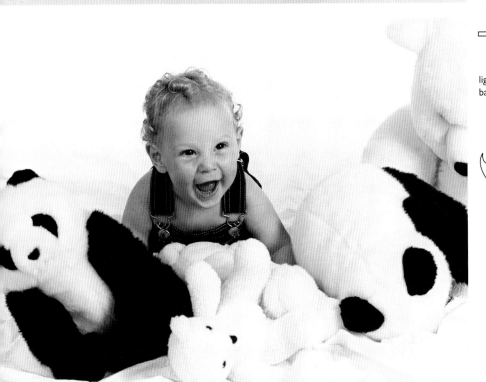

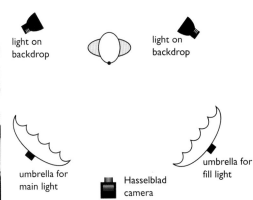

light on
backdrop

light on
backdrop

umbrella for
main light

Hasselblad
camera

umbrella for
fill light

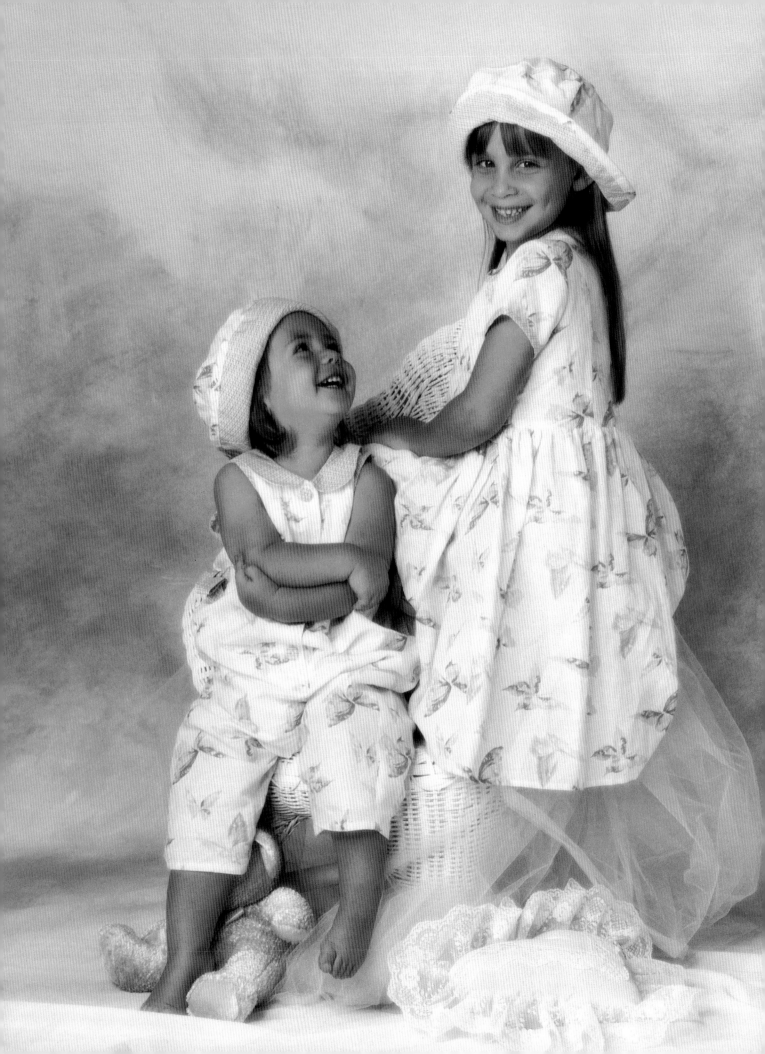

OPPOSITE: Looking up to her big sister with love and laughter is the best it can be. A few matching props to soften the image and it's perfect.

NEAR RIGHT: The fabric the baby is sitting on is lace from the fabric store. Watch for interesting light-weight textures to add softness to your portraits.

FAR RIGHT: Just because he's growing up doesn't mean he's too old for stuffed animals. Don't force boys into trucks and car props too early.

BELOW: Don't use real peaches or you will have a mess in your studio. These crates act like a second background to set off the blond, blue-eyed little girl.

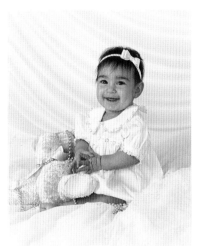
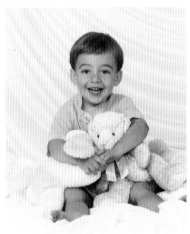

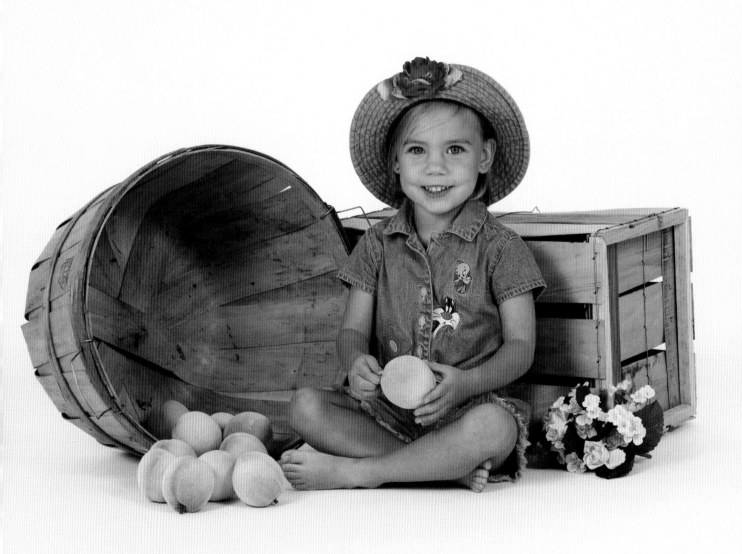

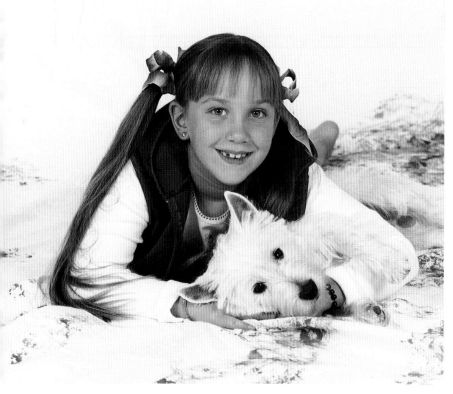

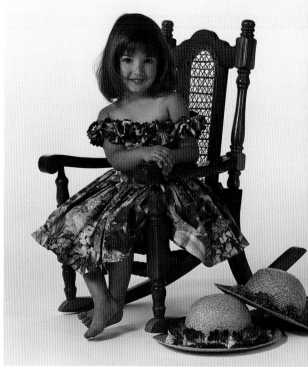

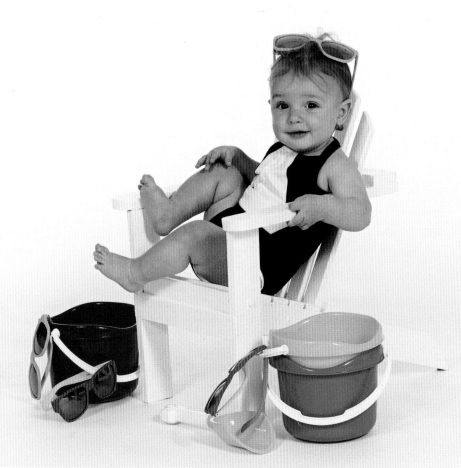

ABOVE, LEFT: A girl and her dog are shown close up and in a fun pose. While photographing pets might be a challenge, they are part of the family and should be included often.

ABOVE, RIGHT: Look for faux antique furniture like this rocking chair at garage sales and second-hand stores. Bare feet enhance the natural summer feel of portraits.

LEFT: Summertime portraits of babies in bathing suits are always adorable. The props are easy to get and the babies love this small chair.

OPPOSITE: Birthday sets are easy and fun to create. This one shows not only her birthday, but also how tiny she really is. A crinkled white background adds some depth to the portrait.

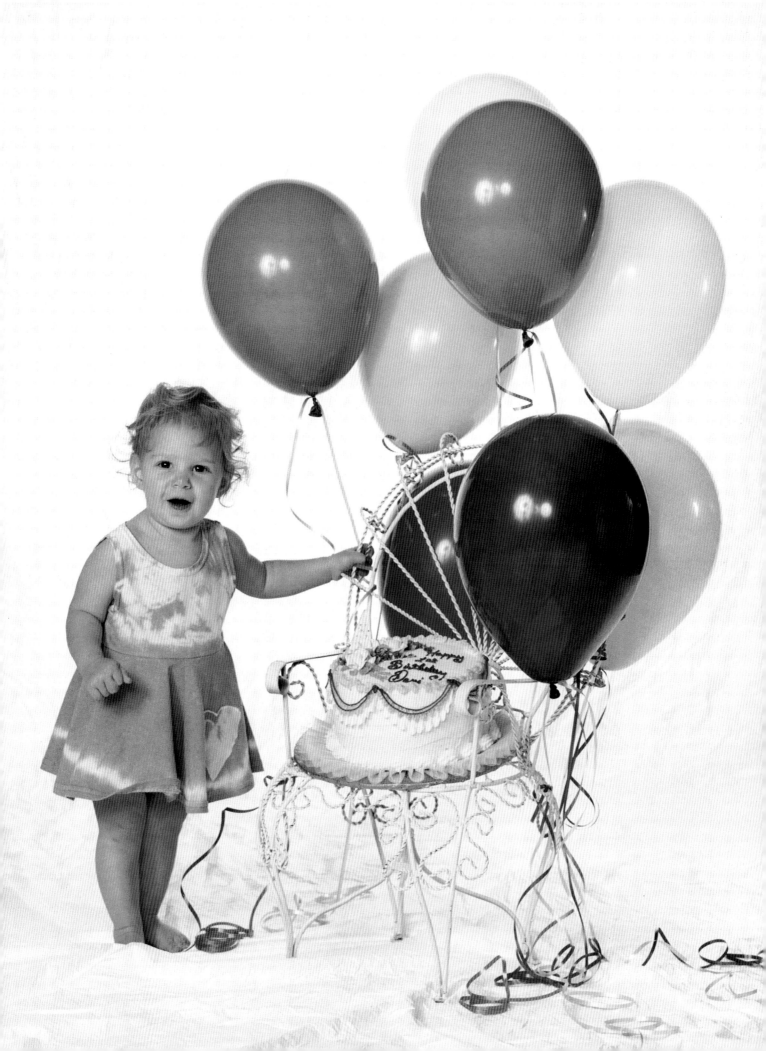

ABOVE: Although this is a studio portrait, it retains much of the natural feel of being outdoors. We encouraged the little boy to pick up things from the sand. It is a unique set that very few studios take the time to set up.

LEFT: Seasonal props help to create a warm set for the fall season.

■ *Finding Your Own Style*

Finding your style has to do with knowing what you are good at and what you like to do. If your outdoor portraits of children are wonderful and natural, then find a twist on them and make it your style. Maybe your look will involve a special soft focus look or a grouping of portraits that tell a story—even a unique location that few know about or have even considered.

■ *Props*

Another trademark of my portraits is unique props. Going out of your way to find resources for studio props that no one else has is worth the time and money it takes to own them. Check out garage sales and flea markets for furniture that can be refinished. The merchandise marts in large cities have gift shows at different times of the year (these shows are for the trade and are where stores buy their merchandise wholesale). As a photographer, you can attend these shows and see everything available, then buy at wholesale prices. Professional photography conventions also have trade shows where manufacturers and dealers display everything a photographer could want to find for props. Be careful not to buy what your competitor is buying—it's as simple as asking the vendor if your competition bought that prop.

BE CAREFUL NOT TO BUY WHAT YOUR COMPETITOR IS BUYING.

■ *Variety*

Your style might even be the variety of portraits and looks you can create in one portrait session. Being known for photographing children in a variety of themes could be another style. One famous photographer created unique baby portraits of babies in flowerpots, making her world-famous for her style. Whatever your style, don't feel locked into it forever. The great artists of the world have been known for their moods. While their basic artistry was consistent, their styles changed as they evolved and learned more about their

art and themselves. If you are known as a color photographer today, there is no reason why you can't be known for your black & whites next year. Keep your mind open and be ready to explore new areas as photographer and artist.

■ *Creativity*

Developing style also involves developing creativity. Many people feel they do not possess creative personalities. However, creative people are not always born that way—many people are creative because they have learned to *develop* creativity in their lives. They have become creative thinkers and problem solvers. The first stepping stone to this is to learn to see everyday objects in new ways. This will lead to your seeing your props and locations in new ways. It expands your vision and allows you to see things differently.

Relationships can be shown without using faces. This group of portraits each tell a story about how small and fragile babies are. Using "edges" on the portraits adds a softer, artistic look to the finished images.

Look at an everyday object such as a towel. Hold it, open it, fold it, throw it in the air and watch how it lands. Clear your mind. Think about how to use a towel, or multiple towels, in a portrait. Sit with your eyes closed and visualize these ideas. Picture a baby and towels and see what emerges in your vision. Then, write down all your ideas. Some ideas that may emerge:

1. Piles of soft, fluffy pastel towels around a nude baby.
2. A pile of pastel towels folded and fluffy with a sleeping baby on top.
3. A baby on her tummy with a towel under her and one just barely over her head like a hood.
4. The baby holding the soft fluffy towel like a favorite baby blanket.
5. Wet the baby's hair and spray her body with a mixture of baby oil and water to make her look like she just got out of the bath, then wrap her in the towel.
6. Lay the baby down on her back on the piles of towels and photograph from a downward angle—as if the baby just woke up.
7. Place the nude baby sitting with the towels and add some baby powder, bottles of baby lotion and stuffed animals for props. Put some baby powder on her to add to the effect.
8. Use the towels as the background of the portrait.
9. Photograph just the baby's face as a very tight close-up with a towel wrapped around her face.
10. Dress the baby in bright fluorescent colors or a tie-dye outfit and find towels in the exact same colors to put all around the baby.

Some other objects to try this exercise with are: baby bottles; flowers; stuffed animals; soft mixed pieces of fabrics;

baby furniture (such as chairs); beads and pearls, and pillows. Think of more objects on your own as you walk around your home.

The point of this exercise is to learn to think outside the box, to go beyond your known uses for these common items. A baby is a new, creative being. That's why, to a baby, the boxes the toys come in are just as much fun as the toy itself. Their minds are open to new experiences and ideas—not caught in the fact that boxes are packaging to be thrown away.

◼ Digital Style

In order to keep your photography in demand, it is essential to continually develop innovative ways to do familiar things. The most interesting and versatile new tool for accomplishing this is digital imaging. On pages 107–108, you will find samples of our new prints that have been manipulated in various programs to create different painting or watercolor effects with assorted edges and borders.

Creating Digital Files. A digital picture is a computer file that "describes" a photograph so that your computer can read it and reproduce it. In the file, the image is broken down into individual pixels on a grid pattern. When put together, much like a jigsaw puzzle, the pixels become a photograph.

WHEN PUT TOGETHER, MUCH LIKE A JIGSAW PUZZLE, THE PIXELS BECOME A PHOTOGRAPH.

Digital picture files can be created by a digital camera, a scanner or by having the files created when your film is processed. What determines the quality of the finished image is resolution. The higher the resolution, the larger the file and the higher quality the finished image will be.

Digital cameras are wonderful, but not necessary if you will only be working on a few special digital files. With a film camera, you can decide on an image-by-image basis to have an image scanned and turned into a digital file. Personally, I still prefer working with film rather than a dig-

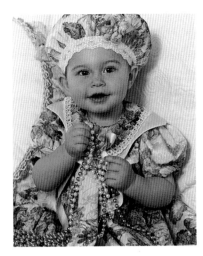

The possibilities offered by adding digital imaging to your repertoire are almost limitless. Giclée printing (after adding a border) turns a nice portrait into a unique work of art.

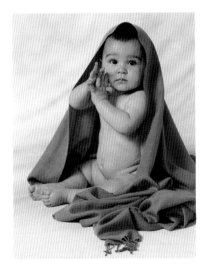

To the right is a close-up of a digital oil painting made from the photograph shown above.

ital camera—but I can see the future will be in digital cameras, eventually.

If you are working with a digital camera, it is imperative that you have a complete understanding of the settings on the camera. Your digital camera will allow a variety of file sizes to be created when taking a picture. If you set it for the most exposures allowed, the files will be quite small and will only print well at the smallest sizes. If you set the file size very high, each image will take up much more memory space, giving you fewer shots on each memory card. Therefore, it is important that you find the appropriate setting for the final print sizes you desire.

Digital Software. You will also need digital software on your computer in order to to color correct, crop and prepare your images for printing. Try some of the new low-cost digital software for image manipulation and see what you can create that is uniquely yours. Keep in mind that, from a single color digital file you can create many different images—black & white, handcolored, sepia, watercolor, etc. You can even make background changes, combine multiple images in one image, add painting—the list goes on and on. You decide what the final image will be.

Four very different versions of one portrait created with digital painting techniques. You can choose one to print, or print all four together (as here) on watercolor paper for added impact.

Outputting Digital Images. After the new digital file is created, special Giclée printers are used to print the images on watercolor paper. Giclée is a French word that means "to squirt or spray." This type of printer creates an exceptionally fine print, applying a million droplets of ink per second—droplets that are the size of a human red blood cell! This printing process, combined with the artistic application of digital watercolor effects to the original photographic images, create one-of-a-kind, original, fine-art images that cannot be duplicated anywhere but at my studio. Other studios may have similar prints or use the same paper, but combined with our special type of image manipulation, they cannot duplicate exactly what I am doing.

When working with digital files your creativity is only limited by your mind. For any given image there are infinite ways to manipulate it.

Software

Below is a list of some software and their manufacturers' web site. These can be used to create various effects to enhance your digital portrait files.

Adobe Photoshop	— www.adobe.com
Adobe Deluxe (amateur version of Photoshop)	— www.adobe.com
Painter	— www.corel.com
Deep Paint	— www.righthemisphere.com
Auto F/X Photo/Graphic Edges	— www.autofx.com
Professor Franklin's Photo Effects	— www.swsoftware.com
Professor Franklin's Photo Artist	— www.swsoftware.com

SALES AND PRESENTATION

The portraits are done and the session went great. Now what? Today, a professional has many options as to how to present the portraits to the clients for viewing and purchasing.

◼ *Presentation*

Traditional Proofs. The old favored method was to present clients with the tried and true "proofs." In this method, the film is sent to the lab and the smallest format prints are made of each and every negative photographed. Then the "proofs" are shown to the client and decisions are made as to what sizes and portraits they will purchase.

Newer methods have been devised to show portraits. One of the main reasons for these innovations becomes obvious to all photographers when they develop their businesses: once people have proofs in their hands, it's hard to get them to order. Invariably, they want to take the proofs home and keep them for weeks in order to get opinions from everyone they know—people who, honestly, just don't count. A client needs a professional opinion and professional help to choose their portraits, not the opinions of friends who don't understand how the portraits may be ordered, framed or work together in a collage grouping.

OPPOSITE: Expressions create emotion. It is impossible to look at this face and not feel something. Be ready to capture these special moments. This is an image that would be hard for Mom to resist owning.

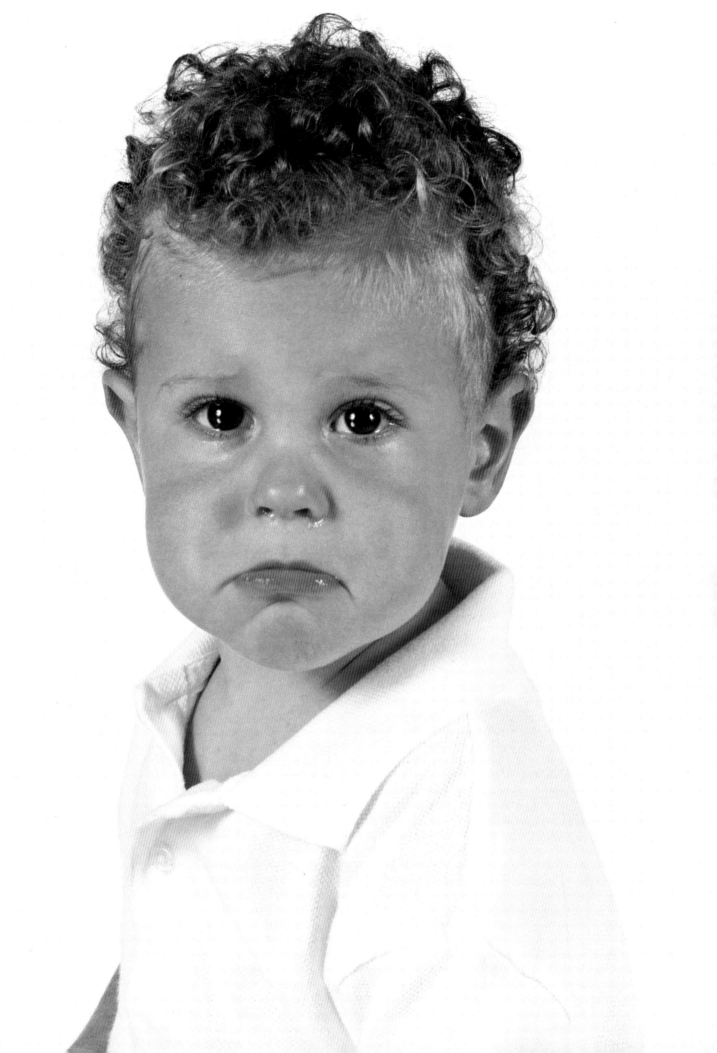

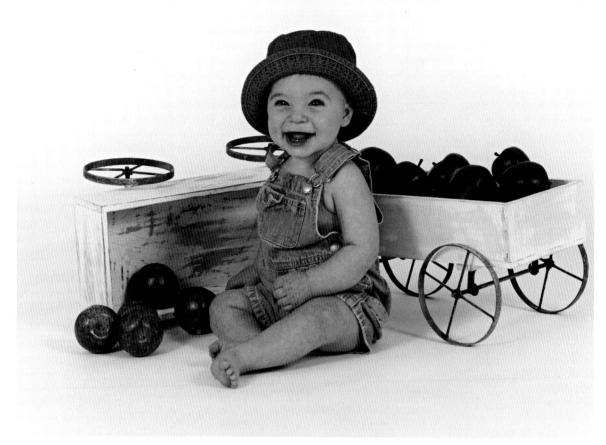

The second reason for not ordering proofs is that, with today's computer equipment, it is easy to make copies of proofs and the client might use them to create very low-quality portraits. There is nothing worse than having your work reproduced and seen by others in the worst possible quality when your intention was to create beautiful, rich looking portraits.

A third reason to not use proofs is the basic costs involved. Proofs are not cheap when you need to shoot a lot of film—and babies and children require a lot of film to truly capture those unique expressions. Nowadays it has become cost prohibitive to print every frame of a session.

Fotovix. There are numerous newer methods of portrait presentation that should be explored, and the final decision is yours. One method is to develop the film (making no

The apples look good enough to eat—but they aren't real! You can find great props like this in home departments. Fake fruit is always a great way to keep a child's attention.

prints) and leave it in a strip. The images can then be presented through a piece of electronic equipment called a Fotovix. Essentially, a Fotovix is a video camera that converts the negative film into a positive image projected through a television set or computer. It's fast, easy to use—and all orders must be placed in the studio as there's nothing to take out of the studio. This method is now extremely popular with professionals.

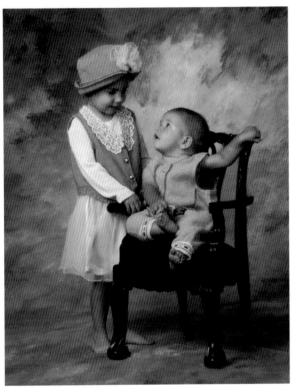
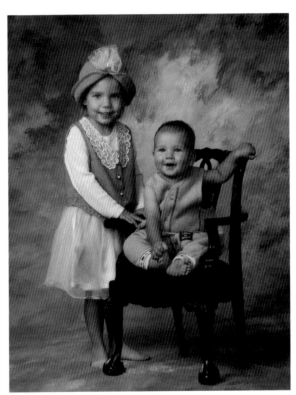

In one portrait session, you can provide considerable variety in just a few minutes. Here are three ways to create portraits that are all equally wonderful and tell a story about the children. All three can be sold together as a grouping.

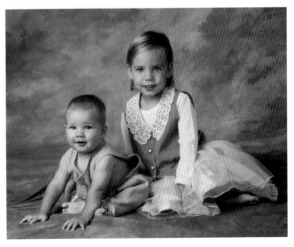

Digital Proofs. Two other methods are computer generated. Both methods are considered digital proofs. One is a method that involves your lab putting all the film on a CD-ROM and viewing the images via computer. The images can then be cropped and viewed on the computer and the order e-mailed to the lab. This method is known as the ProShots® system.

Another system is called Montage®. In this system, the photographer captures the images from the negative with a scanner and inputs all the images into the Montage program. From there, it's easy to sort the images, show multiple images, create albums and place the order. The client views these images either on a computer screen or a television hooked up to the computer.

THE PHOTOGRAPHER CAPTURES THE IMAGES FROM THE NEGATIVE WITH A SCANNER.

Internet Viewing. There are also many new Internet sites that will "post" your portraits online for you or your clients to view. There are two different versions of these sites.

The first version is run by the photographer. Your images are sorted and viewed first on your own personal computer. You may have scanned these in yourself or had them scanned by your lab. The ProShots® program may also have been used. After you sort and select your images, you upload them from your computer to a web site that posts them for clients to see. The clients can even order online, if you permit that.

The second version is run by the lab. You send your film to the lab and they upload it to a site for you to see everything you photographed. This is usually done with 35mm film. There are many amateur sites that will do this for you.

Projection. If going electronic and digital is not possible right now, then consider one of these other two methods. One is "slides" that are created from your negatives. Any professional lab will do this for you. While the cost is essentially the same as paper proofs, it has many advantages over paper proofs. One is that you can show the proofs in the

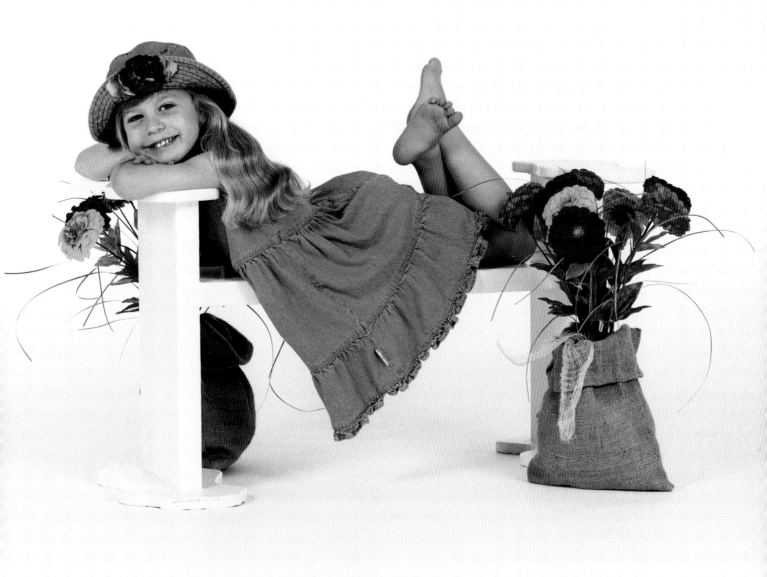

Not every little girl could hold this pose, but this one fell into it and looked like she could stay there forever. Her simple clothing and the flower accents help to keep her face important.

clients' home at the actual size they are considering ordering. Showing an image on the wall where it will hang makes it easy to know if the right size in being selected.

Contact Sheets. A second, even older method is to order only contact sheets of your film. This gives you small images of each frame on your film. You can use a magnifier, called a loupe, to view the images with the client. One photographer I know scans the contact sheets into the computer and then uses Photoshop to enlarge the best images so the client can see them on the computer. This is an effective, fast and low-cost way to incorporate current technology.

■ *Sales*

Nobody really enjoys selling his or her own images. If you are a creative person, you want to spend your time creating. If you are just starting out, you will have to find a way to deal with the selling process until you can hire someone to specialize in it for your business. One way of selling is to think about it as being the end of the creative process. Artists want the client to have the best of their work finished in the manner the artist visualizes it.

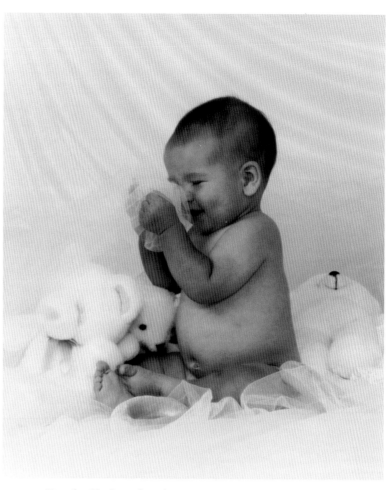

A great expression can be captured when you just let the baby be himself.

The most important quality you need is *enthusiasm!* Be excited about your images on the phone and in person. Be thrilled with what you have created. I once heard a photographer telling a client all the negative things about an image the client was considering purchasing. The client loved the expressions on the children's faces and how cute they were cuddled up together. The photographer pointed out that he didn't straighten the clothing and that the lighting on the background could be fixed with custom printing. Then he added that "Susie's smile is better in this other image, but her arms and legs look a little skinny." After hearing that from the photographer—who is considered the "professional" when it comes to what looks good—the client only placed a modest order and was no longer happy with her imperfect images.

Your optimism about your work will result in good sales. Some things to remember when showing your work are:

1. Don't take it personally if the client doesn't love every image. That's why you are photographing a variety of poses for each client. They need a selection and, inevitably, something will not be their favorite.

2. Be a good listener. This is essential to good sales. Learning to listen patiently and to really hear your client will produce higher sales. They might mention a relative for whom they forgot to order a gift, for instance. Mainly, however, you are listening to their concerns and fears about ordering the prints. This is your moment to reassure them that they are making the right decision and, if anything is not to their liking, that you will stand behind the portraits when they are finished and delivered.

3. Have a consistent system. Every time you show your portraits to a client, use the same method of display and go through the same sales cycle. One such method would be to show the client all the images first and let them know that as you show each one, they don't have to order right away, but just decide if they want to consider ordering it. That way, you can narrow down the images to the ones they like best. After that, you might decide to help them choose their wall portrait, or their gifts. It doesn't matter—as long as the system you follow is the same with every client. That way, it becomes second nature and you will be better able to maintain your concentration.

DON'T TAKE IT PERSONALLY IF THE CLIENT DOESN'T LOVE EVERY IMAGE.

4. Learn when to be quiet. The biggest mistake people make when selling is talking too much. Don't push the client to make snap decisions. Relax, sit back and listen to the client speak about each portrait. Reinforce their enthusiasm about their favorites and be quiet about the ones they don't like.

5. Keep your sense of humor. Remember how silly that child was in the camera room during the photography session? Remind Mom how he made you laugh that day, and enjoy seeing her smile as she thinks about him.

6. Speaking of the children, remember to schedule the sales appointment when the children will not be around. It's hard for a parent to make decisions when their children are distracting them.

◼ Conclusions

Selling portraits follows the same sales rules as selling anything else. Look in your phone book for some courses for sales professionals. Check out the business section of your Sunday paper for sales classes. Take as many as you can, as often as you can. Once the sales process feels natural to you, you won't need the classes, but until then, let a professional teach you to be more comfortable with the sales process.

SELLING PORTRAITS FOLLOWS THE SAME SALES RULES AS SELLING ANYTHING ELSE.

CUSTOMER SERVICE AFTER THE SALE

This is a much forgotten area of sales and service. Customer service can make or break your reputation in your community. One happy customer will tell two people. One unhappy customer will tell twenty-five. It is your job to say thank you many times over, in many different ways, to each and every client. Your clients did you the honor of purchasing your portraits. What better way to say thank you than with the gift of a few wallets, or an extra print of an image they did not order but that was one of your favorites—or maybe a gift certificate good on their next portrait session. There are many ways to let your clients know you appreciate their business. These are just a few of them.

■ *Thank-You Notes*

I remember when my friend bought his first sports car. It was a lifelong dream that he finally attained and he was thrilled to drive it off the lot. As excited as he was to buy the car, what brought him back to that same dealership three years later to update his purchase was the thank-you note he received a week after the purchase. The day he went to pick up the car, the salesman asked if he could take his pic-

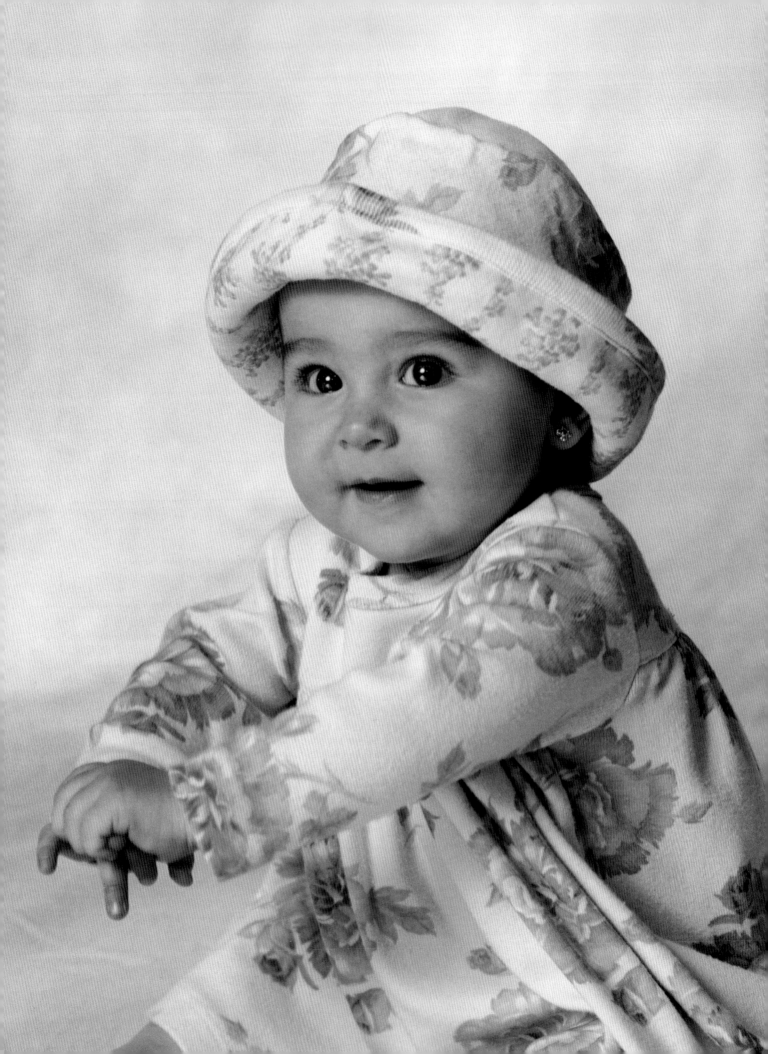

ture with the car as a favor, since he likes to keep the pictures on his office wall. The thank-you note was that picture with a handwritten personal note from the salesman. What an impact that made on my friend!

The power of thank-you notes is never to be underestimated. And the more unique the thank-you note, the more memorable you will be. Some of the nicest ones can now be done on your own ink-jet printer with an inexpensive scanner. Scan your favorite photo and print a few notes. In the first note, put your handwritten thank you. Give the client the other four blank notecards for their own use.

This creates not only good will, but increases your professional visibility, since the client will probably send out the other notecards to friends and family. For this reason, your studio name and phone number should be printed on the back of the notecards.

Mailings

To make customer service even simpler, there are a number of products on the market to help you achieve your goals in customer service. For example, you may want to send birthday cards to the children you have photographed (this is a great reminder to parents to update their child's photo, as well). Another item you may want to use is a customer satisfaction card that can be sent to clients to evaluate your studio. You can also stay in touch with clients by sending them a postcard showing one of their images or an exciting and new portrait on the front. One provider of this service is the web site www.amazingmail.com. This company will print and mail a custom-made postcard for you.

A NUMBER OF PRODUCTS ARE ON THE MARKET TO HELP YOU ACHIEVE YOUR GOALS.

Phone Calls

Good customer service also means calling clients before making a special offer to the public. Give them first choice

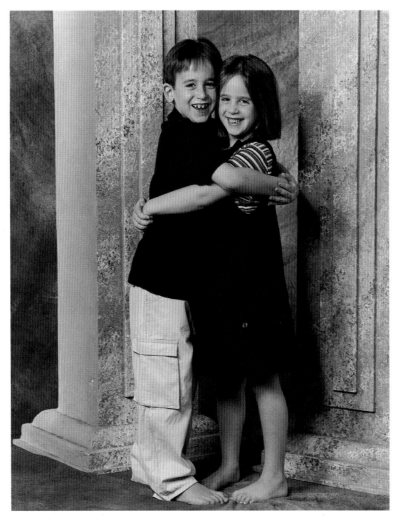

This brother and sister happily followed directions to give each other a huge hug. The columns add depth and are placed away from the background. The background is lit with its own background light.

of appointment times. You can also call clients just to ask how the children are—never underestimate the value of simply saying hello. Often, when you make this call you will find you have reminded them that they wanted to update their family portrait.

▪ E-Mail

Another way to keep in constant contact with your clients is to request their e-mail addresses. Holiday cards can be sent via e-mail as can announcements, newsletters, special offers—and don't forget to just say hello via a short e-mail once in a while. This makes it easy to stay in touch with clients.

Hints and Tips
Remember the children's names and the names of their cousins (who you have also probably photographed). Remembering relationships between your clients is important and shows that you care about their family, not just the last portrait session.

Web Sites

The Internet was practically designed for professional photographers! It is perfect for showing your work and giving potential clients a tremendous amount of information about you. That is why it is important to have a web site for your studio. Your web site should be professional, easy to navigate and, on the first page, have all the information needed for clients to contact you. They can either call or e-mail from the web site. Check out my web site (www.marilynsholin.com) for additional information.

THE INTERNET WAS PRACTICALLY DESIGNED FOR PROFESSIONAL PHOTOGRAPHERS!

Customers for Life

All of this leads up to the building of customers for life. You become part of their family and they become part of yours. When you photograph children, it's a sure bet you will be photographing them year after year (and probably some of their relatives, too). To see a grandma holding her first great-grandchild is an awesome sight through the camera. It's a moment you are sharing with her and the entire family. You can't help but feel that you are a small part of their lives. Extend that feeling to everything you do, and your clients will return time after time.

Hints and Tips

It's not unusual to send "toy dollars" to the children for their birthdays or give little gifts to them before they leave the studio. We have always found stickers very popular at the studio. Children love to be given a choice of them and always need more than one. During the holidays it's nice to gift-wrap small gifts so the children have something to open at the end of the session. It's not so much a bribe as a gift.

CONCLUSION

Treat your clients' babies and children like they are your own. Then you will reap the same rewards as you do with your own children. Yes, they can be mischievous and downright impatient sometimes, but overall, they are just little people asserting their rights. Treated with respect, love, kindness and humor will give you the best photography days of your career. And above all, remember the most important characteristics one needs to be a baby photographer: humor and patience!

EQUIPMENT AND SUPPLIERS

■ *Camera*

All the images in this book were produced with a Hasselblad camera using Hasselblad lenses (150mm and 80mm).

Hasselblad, USA
(201)227-7320
www.hasselblad.com

■ *Lighting Equipment*

Photogenic Power Lights
(800)682-7668

■ *Backdrops*

Artistic Backgrounds by Gail Degman
(208)535-1323

Joe Proscia at the Backgrounders
(818)508-8908

■ *Film*

Kodak VPS, Portra 160NC, 160VC, 400NC, 400VC, TMAX 100, TMAX 400 CN
(800)657-5213
www.kodak.com

■ *Off the Wall*

Studio Props
(800)792-5568
www.offwallprod.com

■ *Photo Labs*

Miller's Professional Imaging
Customer Service: (800)835-0603
www.millerslab.com

Jonathan Penney Black and White
Black and White Darkroom Services
176 Main Street
Center Moriches, NY 11934
(516)874-3409
jpenney@bwdarkroom.com
www.bwdarkroom.com

SWG
Black & white printing, film developing
8 NE 40 Street
Miami, FL 33137
(305)573-7020

PROSHOTS
www.proshots.com

■ *Organizations*

PPA (Professional Photographers of America)
www.ppa-world.com

■ *Equipment and Education*

www.photoalley.com
www.zuga.com
www.prophotoplace.com

Marilyn Sholin is available for personal and small group consultations in the areas of portrait photography and general business management of a studio. She is also available as a speaker for workshops, schools and conventions. Please contact her at msholin@ marilynsholin.com, or via her web site: www.marilynsholin.com.

INDEX

Other Books from
Amherst Media™

Master Posing Guide for Portrait Photographers

J. D. Wacker

Learn the techniques you need to pose single portrait subjects, couples and groups for studio or location portraits. Includes techniques for photographing weddings, teams, children, special events and much more. With this book, you'll make every subject look his or her best! $29.95 list, 8½x11, 128p, 80 photos, order no. 1722.

Portrait Photographer's Handbook

Bill Hurter

Bill Hurter has compiled a step-by-step guide to portraiture that easily leads the reader through all phases of portrait photography. This book will be an asset to experienced photographers and beginners alike. Features photographs by top portrait artists from around the country! $29.95 list, 8½x11, 128p, full color, 60 photos, order no. 1708.

Professional Secrets of Natural Light Portrait Photography

Douglas Allen Box

Learn to utilize natural light to create inexpensive, flattering and hassel-free portraiture. Beautifully illustrated with detailed instructions on equipment, setting selection and posing. Includes techmques for photographing children, families, weddings and much more.$29.95 list, 8½x11, 128p, 80full color photos, order no. 1706.

Photographing Children in Black & White

Helen T. Boursier

Learn the techniques professionals use to capture classic portraits of children (of all ages) in black & white. Discover posing, shooting, lighting and marketing techniques for black & white portraiture in the studio or on location. $29.95 list, 8½x11, 128p, 100 photos, order no. 1676.

Family Portrait Photography

Helen Boursier

Learn from professionals how to operate a successful portrait studio. Includes: marketing family portraits, advertising, working with clients, posing, lighting, and selection of equipment. Includes images from a variety of top portrait shooters. A complete package for success! $29.95 list, 8½x11, 120p, 123 photos, index, order no. 1629.

Outdoor and Location Portrait Photography

Jeff Smith

Work with natural light, select locations, and make clients look their best. Step-by-step text and illustrations teach you how to shoot outdoor portraits like a pro! $29.95 list, 8½x11, 128p, 60+ b&w and color photos, index, order no. 1632.

Traditional Photographic Effects with Adobe Photoshop

Michelle Perkins and Paul Grant

Use Photoshop to enhance your photos with handcoloring, vignettes, soft focus and more. Step-by-step instructions for easy learning. $29.95 list, 8½x11, 128p, 150 photos, order no. 1721.

Professional Secrets for Photographing Children

Douglas Allen Box

Photograph children on location and in the studio. Prepare children and parents for the shoot, select the right clothes capture a child's personality, and shoot story book themes. $29.95 list, 8½x11, 128p, 74 photos, index, order no. 1635.

More Photo Books Are Available

Contact us for a FREE catalog:

AMHERST MEDIA
PO BOX 586
AMHERST, NY 14226 USA

www.AmherstMedia.com

Ordering & Sales Information:

INDIVIDUALS: If possible, purchase books from an Amherst Media retailer. Write to us for the dealer nearest you. To order direct, send a check or money order with a note listing the books you want and your shipping address. Freight charges for first book are $4.00 (delivery to US), $7.00 (delivery to Canada/Mexico) and $9.00 (all others). Add $1.00 for each additional book. Visa and MasterCard accepted. New York state residents add 8% sales tax.

DEALERS, DISTRIBUTORS & COLLEGES: Write, call or fax to place orders. For price information, contact Amherst Media or an Amherst Media sales representative. Net 30 days.

1(800)622-3278 or (716)874-4450
FAX: (716)874-4508

All prices, publication dates, and specifications are subject to change without notice. Prices are in U.S. dollars. Payment in U.S. funds only.